PLYMOUTH
From Old Photographs

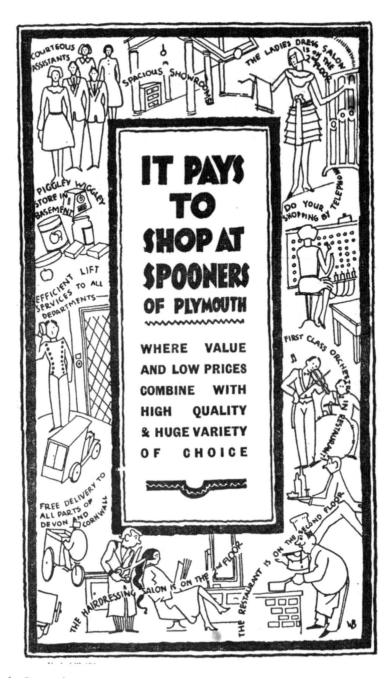

An Advert for Spooner's, *c.*1932

Spooner's was one of the most well-known shops in pre-war Plymouth. Spooner's Corner was a popular meeting place and like many other shops in the town, it had its own own orchestra playing in their restaurant. The shop featured its own fashion department taking up one floor and it even had its own theatre to perform fashion parades. In 1902, Spooners was nearly totally destroyed by a fire when a shop assistant accidently set fire to a display commemorating the coronation of King Edward VII. Spooners survived until the Blitz of 1941 and was eventually rebuilt on Royal Parade.

PLYMOUTH
From Old Photographs

DEREK TAIT

AMBERLEY

First published 2011

Amberley Publishing
Cirencester Road, Chalford,
Stroud, Gloucestershire GL6 8PE

www.amberleybooks.com

British Library Cataloguing in Publication Data.
A catalogue record for this book is available from the British Library.

ISBN 978-1-4456-0424-4

Typeset in 10pt on 12pt Sabon.
Typesetting and Origination by Amberley Publishing.
Printed in Great Britain.

Contents

Introduction

Plymouth in the late 1800s was very different place than it is today. There were no cars, no televisions, no radios and no electric lighting. There were no superstores and most groceries were bought from the local corner shop, which would quite often sell rabbit and pheasant along with the usual wares.

Luckily though, there was photography. Basic photography had its origins in the early 1800s. With vast progress by Fox Talbot, the demand for photographs grew. In the 1850s there were only a handful of photographic establishments, but by the end of the century there was a craze for photography. Shopkeepers, businessmen and many of the middle class people would have their images reproduced on postcards to keep or to send to their families. Photographic studios were kept constantly busy and there were many of these in Plymouth. Two-thirds of the photographers in Plymouth in the early 1900s were situated in Union Street. Few people had their own cameras, so they would visit the photographer to have portrait or family shots taken. Some studios could even accommodate up to fifty people in one photo. Unfortunately, a lot of these old photographs have been destroyed: either burnt or consigned to the rubbish dump. However, many of these early photographs and postcards have survived and some are reproduced in this book.

Plymouth at the beginning of the twentieth century was effectively three towns: Plymouth, Stonehouse and Devonport. In 1901, the population of the three towns was nearly 193,000. The three towns expanded to take in many rural areas. In 1896, Western Peverell and Compton became part of Plymouth and in 1898, St Budeaux and Saltash Passage and Pennycross became part of Devonport.

Transport played a big part in linking the towns. Plymouth's first tramway was opened in 1872 by the Plymouth, Stonehouse & Devonport Tramways Company. Before the advent of electricity, the trams were pulled by horses and the 4 foot 8 inch track ran from Derry's Clock, along Union Street, over Stonehouse Bridge, and ended at Cumberland Gardens in Devonport.

In 1874 the line was extended to run to Fore Street in Devonport. Electric trams took over from the horse drawn ones in the early 1900s and the service eventually covered most of the area known today as Plymouth.

After much disagreement, Plymouth, Stonehouse and Devonport were amalgamated into one town in 1914. Plymouth became a city in 1928. Pre-war Plymouth – at the turn of the century – was a bustling, vibrant town with many popular shops such as Dingle's, Goodbody's, Popham's and John Yeo's. Popham's toyroom boasted a stock of 2,000 dolls in 1882 and Goodbody's was famous for its restaurant, where the Royal Marines Band would play in the afternoon. Dingle's also had its own band – the George East Orchestra.

The people of Plymouth were not short of entertainment. There was a wealth of theatres in the town. There was the Grand Theatre in Union Street, famous for its Christmas pantomimes; the Theatre Royal, which opened in 1813; the Palace Theatre of Varieties, which opened in 1898; and the Hippodrome, which opened in 1908. The Hippodrome was later converted into a cinema to welcome the arrival of talking movies in 1929. Some of the acts that came to Plymouth included Harry Houdini, Lillie Langtry, Buffalo Bill, and Laurel and Hardy.

People could catch a tram or walk to the pier and stroll the boards or watch the many attractions that took place there. The Hoe was alive with entertainment, including local military bands, dancing, annual regattas and regular swimming events.

The Second World War turned Plymouth upside down. Plymouth and Coventry were the worst-hit areas in Britain and the heavy bombing all but obliterated Plymouth. Food was rationed, and during the blackout, people were afraid to even strike a match for fear of enemy attacks. Thick blackout material could be bought at 2s a yard and this was used to stop the slightest glint of light escaping from buildings. At night, it was difficult to find your way about or to be seen, and it was suggested that more people died from traffic accidents in Britain than from enemy bombing. There were certainly many fatalities due to vehicles travelling with hooded or no lighting – with no street lighting, it was very hard to walk or drive through the town at night.

During bombing, sirens would sound and mothers would take their children to the Anderson shelters in their gardens. Some even headed out into the country and the moors to avoid the shelling. The next day, those who could got on with their lives while the homeless were cared for in government rest centres, where the Voluntary Service would provide cups of tea and blankets.

Heavy bombing during the Blitz of 1941 changed the face of Plymouth forever. Along with widespread devastation, 1,174 civilians lost their lives and 3,269 were seriously injured. Over 5,000 buildings were destroyed and 80,000 damaged. Plymouth would never be the same again.

Major shopping areas like Bedford Street, Spooner's Corner and Old Town Street were reduced to rubble and many other well-known streets were also completely destroyed. The heart of the city was totally devastated, leaving just St Andrew's church, the Guildhall (although both very severely damaged), the *Western Morning News* building, and the Regent Cinema (later Littlewood's) in the main part of town.

Winston Churchill visited the city in 1941 and saw the devastated areas and was said to be visibly shaken. Huge crowds turned out to see him as he toured the remains of the city. Cries of 'Give it to them back!' were heard.

There are few surviving buildings or streets of the old city although the Hoe, apart from the pier and bandstand, remains pretty much intact.

Plymouth was seen as a blank canvas to start again and work got underway to rebuild the city in 1947. Its main feature, Royal Parade, remains much the same as it was then.

By 1959, over £8 million had been spent on land acquisition by the reconstruction committee of the city council. Huge areas of Plymouth had been demolished and were rebuilt as new homes and businesses. In the early 1950s, Woolworth's, Dingle's, John Yeo's and Timothy White's re-opened for business. Plymouth was seen then as a very modern city with its three main shopping streets and the long stretch of Armada Way leading down from the Hoe straight through the centre of the city. Reconstruction finally ended in 1962 with the opening of the Civic Centre by the Queen on 26 July, some twenty-one years after the Blitz.

An ever-growing city, Plymouth is constantly changing and expanding. Many of the buildings and shops in New George Street, Cornwall Street and Royal Parade have changed little since the reconstruction after the war, although much major building work has taken place nearby in recent years.

I hope this book will bring back many memories for the older generation and introduce younger generations to the varied and interesting history of Plymouth.

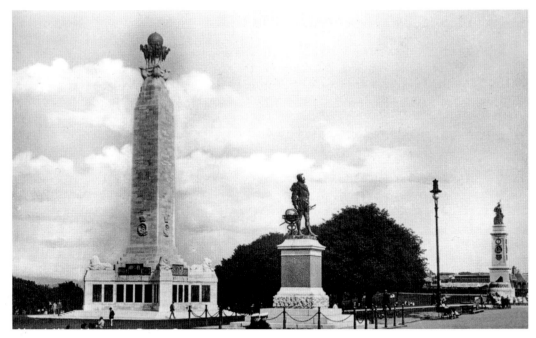

The Hoe, *c.* 1920s
One of Plymouth's most popular landmarks and tourist attractions, the Hoe has seen generations of visitors. The Naval Memorial can be seen in the foreground with Drake's statue and the Armada memorial in the background.

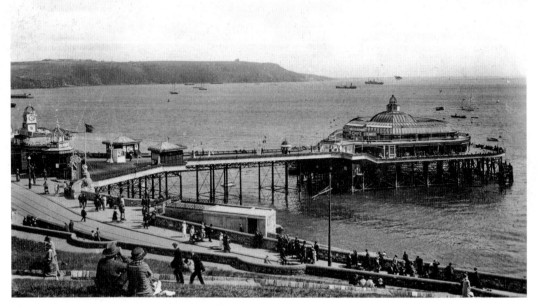

The Pier and Staddon Heights from Plymouth Hoe, *c.* 1920
The pier was opened on 29 May 1884 and featured slot machines, a stationers and bookstall, a reading room and a post office. Pleasure-steamer trips left from the iron stairways that led down to the water.

CHAPTER ONE

In the Town

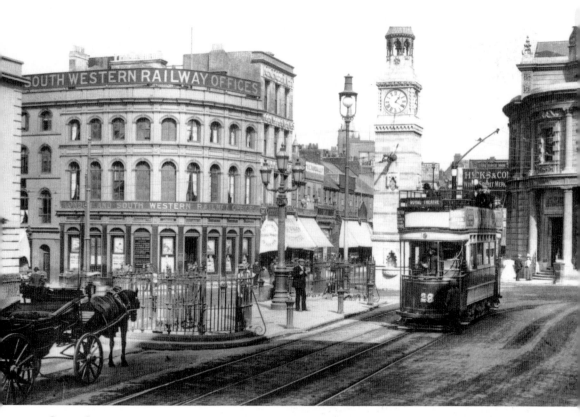

George Street, *c.* 1910

Derry's Clock can be seen in the middle of the picture. All trams terminated there and the clock was a common meeting place for young sweethearts – although it was known as the four-faced deceiver, because the clocks on all four sides appeared to show different times. Lloyds Bank can be seen on the right of the picture; one of the few buildings still standing after the Second World War, it is now the Bank Public House.

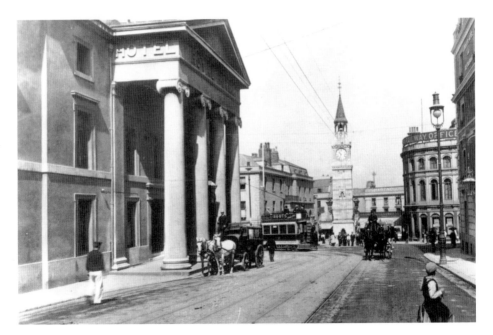

Lockyer Street, *c.* 1906
The Royal Hotel can be seen on the left. This adjoined the Theatre Royal in George Street. Work was started on the building in 1811 from plans drawn up by John Foulston. It took two years to complete at a cost of £60,000. A casualty of the Blitz, the site was occupied for many years after by a small car park. Opposite the Royal Hotel can be seen the Lockyer Hotel.

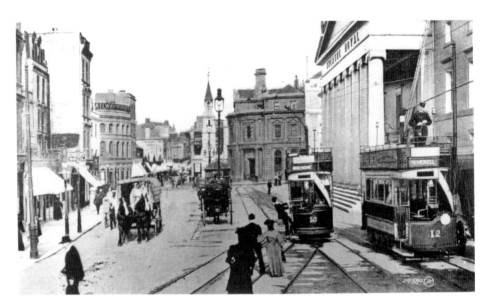

George Street, *c.* 1910
A busy area where trams and coaches all met to drop off or pick up passengers. 'Theatre' was a popular destination and the Theatre Royal can be seen on the right of the picture. Opened in August 1813, it could seat almost 1,900 people. It survived until 1937, when it was demolished so that a new cinema could be built, the ABC Royal.

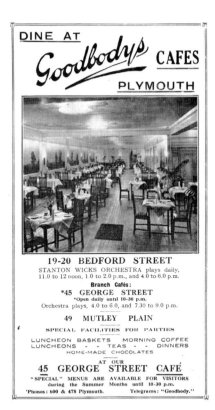

An Advert for Goodbody's Cafés, *c.* 1932
Goodbody's was a popular café and meeting place, situated at 19–20 Bedford Street, where the Stanton Wicks Orchestra would play daily. They also had smaller cafés at George Street and on Mutley Plain before the Second World War.

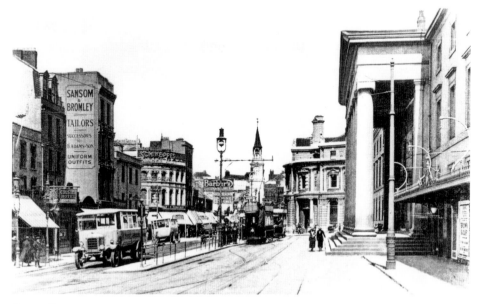

George Street, *c.* 1924
Gone are the horses and cabs that queued outside the Theatre Royal to take people home. Buses, which ran side by side with trams for many years, have appeared. George Street featured a wide variety of shops including confectioners, tailors, hatters, watchmakers and even an umbrella maker.

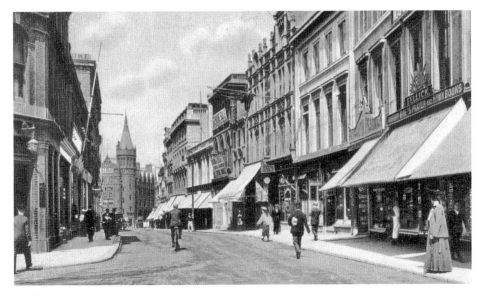

Bedford Street, *c.* **1905**

Pre-war Bedford Street was a bustling, vibrant street known for its popular shops such as John Yeo's, Dingle's and Popham's. John Yeo's was well known for its range of blankets and haberdashery and Popham's for its goods, including jewellery and gloves aimed at the middle classes. George East and his Trio played in Popham's lavish restaurant and having tea there was compared to having tea at the Savoy.

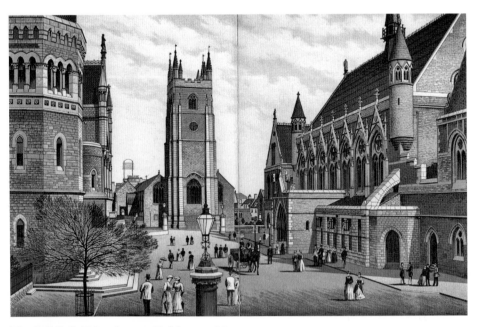

The Guildhall, Taken from an Etching, *c.* **1887**

The Guildhall was built between 1870 and 1874 at a cost of £50,000. It was almost completely destroyed by the Blitz of 1941 when only its outer shell remained. It was originally built by a local man, John Pethick, who later became Mayor in 1898.

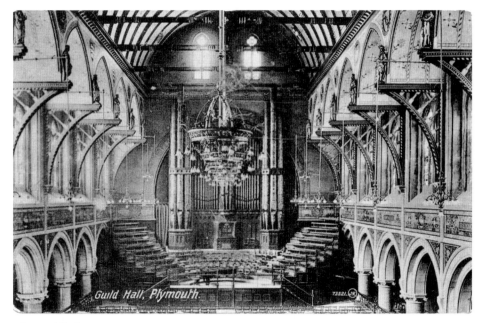

The Guildhall Interior, *c.* 1910
The great hall, which was 146 feet by 58 feet, was totally destroyed by the bombing of 1941 and it took another ten years to decide whether to rebuild or demolish it completely. It was finally decided to rebuild it and it was re-opened in 1959, some eighteen years later.

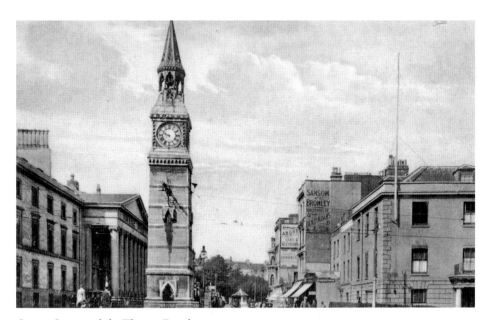

George Street and the Theatre Royal, *c.* 1915
The landmark of Derry's Clock can be seen clearly in this picture. It survived the Blitz and still stands behind the new Theatre Royal. There have been many suggestions about moving it but it still remains in its original location – though anyone from the turn of the 1900s viewing it now would have difficulty recognising any of its surroundings.

An Advert for Popham's, *c.* 1920

Popham's was a very popular shop in pre-war Plymouth and was known as the Harrods of the West. It catered for the city's well-heeled and county set, and there was a certain snobbery about being employed there. After the war and the reconstruction of Plymouth, Popham's re-opened on Royal Parade.

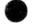
An Advert for Jaeger Wear, *c.* 1920

Situated in Old Town Street, Jaeger Wear was founded in 1884 by Dr Gustav Jaeger, a zoologist who thought that if animals were healthy with wool against their skin then humans would be too. The idea was taken up by an English grocer, Lewis Tomalin, who bought the patent and produced 'Dr Jaeger's Sanitary Woollen Wear'.

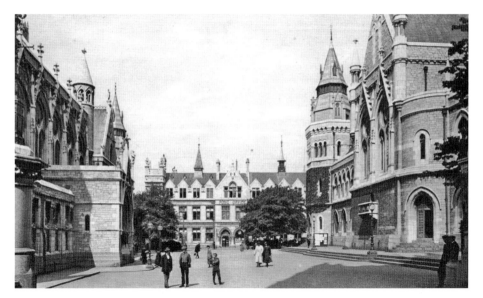

The General Post Office, *c.* 1910
The post office stood in Westwell Street, looking down from Princess Square, and was once a popular point of call. It was opened in 1884 and was built of Portland Stone at a cost of £16,500. It was designed by E. G. Rivers of Bristol. Its interior was reconstructed in 1933 and it featured an inlaid floor depicting Sir Francis Drake's ship and the *Mayflower*. Also featured in this picture are the Guildhall and the Municipal Buildings.

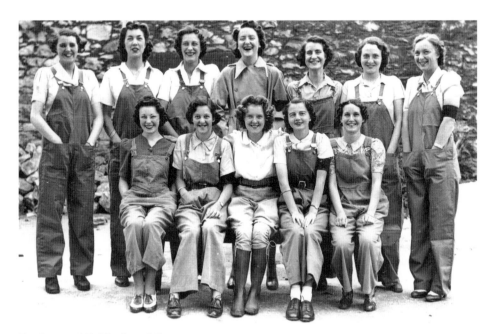

Employees of E. Dingle and Co., 1939
Dingle's was situated in Bedford Street and this photograph shows some of the staff who worked there. They gave up their two weeks' holiday to work on the land as part of the war effort in 1939. Barbara Hill, age eighteen, is in the middle of the front row, wearing Wellington boots.

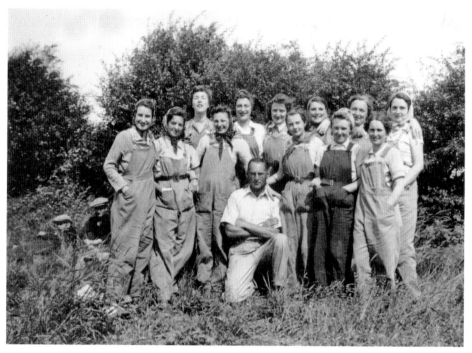

The Dingle's Staff with the Landowner, on His Farm in 1939
With the men away fighting during the Second World War, land girls played a vital role in keeping the country going. They took on a wide variety of agricultural work on farms including ploughing, harvesting and haymaking.

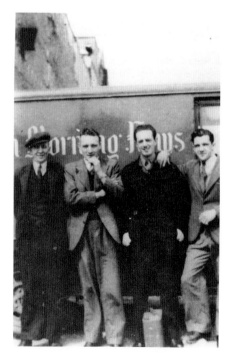

***Western Morning News* Delivery Drivers, 1940**
The *Western Morning News* van was a popular sight in Plymouth delivering newspapers to various shops around the city. The deliveries continued in darkness during the blackouts of the Second World War. Featured in this photograph on the far left is Percy Colton with his brother, Sid, standing next to him.

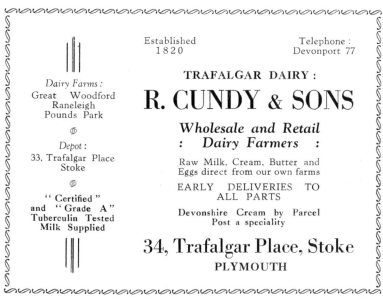

An Advert for R. Cundy & Sons, *c.* 1920s

R. Cundy & Sons were better known as the Trafalgar Dairy. They were based at Trafalgar Place in Stoke and had been established since 1820. Their produce included raw milk, cream, butter and eggs direct from their farms.

An Advert for Hicks and Co., *c.* 1920

Hicks & Co. were wine merchants located at 3 Wembury Street. They were suppliers to the Royal Navy and the Army and also agents for Carr's Cider. They also supplied the Duke of Cornwall Hotel.

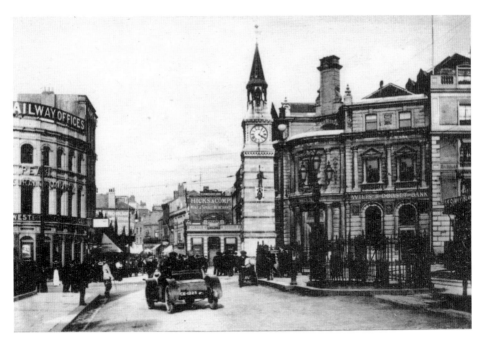

Derry's Clock and George Street, *c.* 1923
Derry's Clock was presented to the town in 1862 by William Derry and was worth £220, which was half the costof the tower built to house it. Plymouth didn't have the authority to erect a clock, this had to be given to them by Parliament, so Derry's Clock was officially a fountain, although it has never been connected to a water supply.

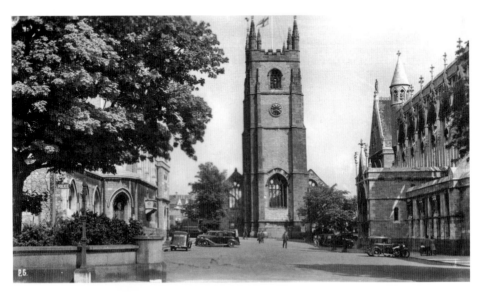

Parish Church of St Andrew and Guildhall Square, *c.* 1940s
Before the war, St Andrew's church was located on the southern side of Bedford Street. A church is believed to have stood on this spot since before 1264. The tower dates from 1461 and the labour to build it was paid for by a wealthy local merchant, Thomas Yogge.

An Advert for Boots the Chemists, *c*. 1932

The original Boots shop was founded by John Boot in the 1840s. Boots has had a chemist shop in the city since long before the Second World War. In total, thirty-three branches of Boots were destroyed in Britain due to enemy action. Some Boots stores were used as first-aid posts and the staff took civil defence tests and worked as air-raid wardens.

An Advert for the Three Towns Dairy, *c*. 1932

Even before the war, the Three Towns Dairy would send clotted cream all around the country by post. Many people's first taste of clotted cream would have come from this well-known dairy situated in Union Street. They also had cafés at 52 Union Street and 8 Westwell Street, and their advert proclaimed 'Devonshire Dainties our Speciality'.

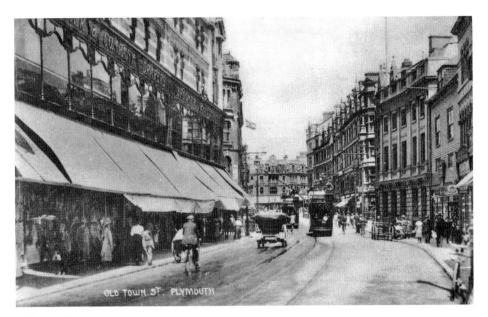

Old Town Street, *c*. 1905
Bombed extensively in the Second World War, the only part of the city that retains the name of Old Town Street is by the main post office at the top of Royal Parade, which stretches towards New George Street. Old Town Street before the war featured many well-known stores, including Woolworths, Mumford's, La Brasseur, and Notcutt the photographers.

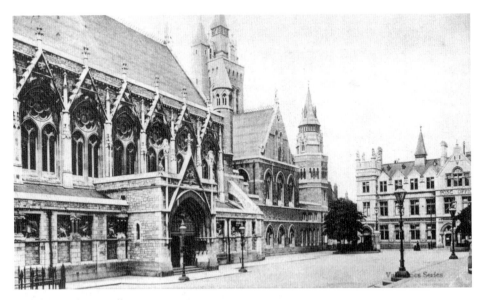

Guildhall and Post Office, *c*. 1917
Plymouth Chamber of Commerce was first established at the Guildhall on 28 December 1813. Under the trusteeship of the Earl of Mount Edgcumbe, Lord Eliot, Lord Boringdon, the Duke of Bedford and Mr Carew MP, its main objectives were to rejuvenate home and foreign fisheries, to begin whale fisheries in the South Seas and Greenland, and to establish a trade with the West Indies for rum, sugar, coffee and molasses. They also planned to regenerate many of the town's old industries.

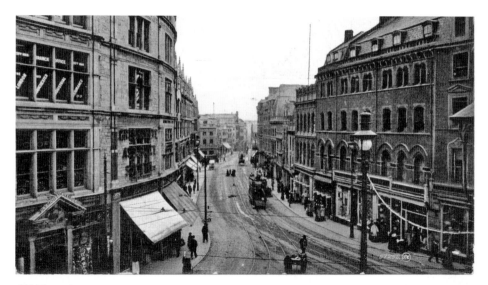

Old Town Street, *c.* 1905

Plymouth Chambers can be seen on the left of the picture. Above are the London and Manchester Industrial Assurance offices. Walking down the road, though you need good eyes to see him, is a man with a sandwich advertising board. Old Town Street stretched from Spooner's Corner up to Tavistock Road. In the 1700s, Plymouth consisted of just 1,600 houses, all around Sutton Harbour. The northern end of the town was where the top of Royal Parade is today, and Old Town Street led out into open countryside.

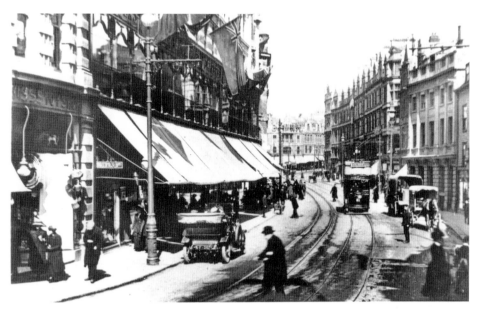

Old Town Street, *c.* 1910

A busy shot of Old Town Street showing cars and trams running alongside each other. A horse and cart can also be seen in the background. Old Town Street was continually widened over the years for ever-increasing forms of traffic. The building at the end of the street stood for many years after the war and carried a large sign saying, 'Guinness is good for you.'

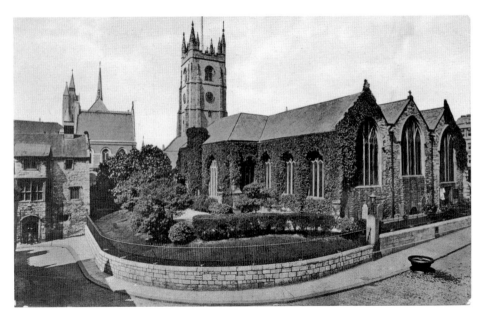

St Andrew's Church, *c.* 1910

St Andrew's was known as the mother church of Plymouth. William de la Stane was the first recorded vicar there in 1264. It is the largest parish church in Devon and is 184 feet long and 69 feet wide. The morning after St Andrew's church was bombed in the Second World War, someone placed a wooden sign over the north door with the word 'Resurgam' written on it, meaning, 'I will rise again.' The word is now carved in stone above the main door.

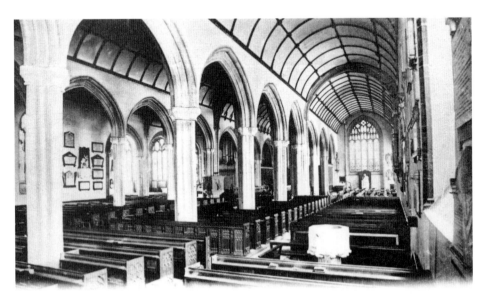

St Andrew's Church Interior, *c.* 1920

In March 1941, St Andrew's church became a ruin after a bombing raid on the city. The roof and all the fittings were destroyed. For a while, the empty shell became a garden church, which many people enjoyed visiting. It wasn't until 1949 that repair work was considered, and eventually rebuilding was completed in 1957.

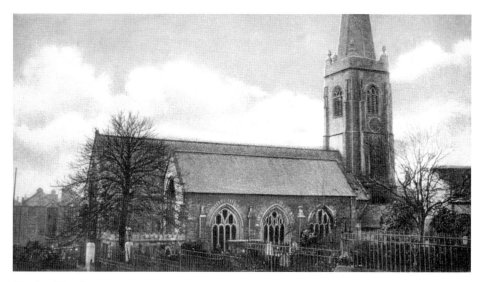

Charles Church, *c.* 1920
King Charles I gave his permission for a new church to be built in Plymouth in 1641 and it was completed in 1658. It was known then as 'The Church of Plymouth called Charles Church'. Its tower was not completed until 1708 and the spire was made of wood covered with lead until 1766. It was bombed in 1941 and its remains can still be found on the Charles Cross roundabout as a memorial to Plymouth's war dead.

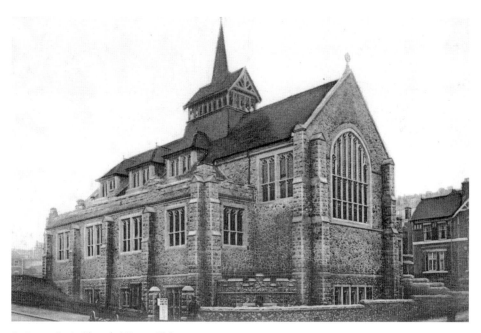

St Augustine's Church, Lipson Vale, *c.* 1920
St Augustine's church was situated at Alexander Road, Lipson. Work was started on the church in 1899. It was a mission church until it was consecrated in 1905. The church was made of granite and was Gothic in style. After being damaged in the Second World War, it was rebuilt, but was demolished in the early twenty-first century.

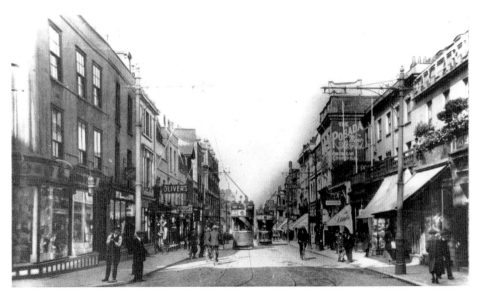

Union Street, *c.* 1905
John Foulston designed Union Street in 1811 to link Plymouth with its neighbours, Devonport and Stonehouse. Shops that can be seen in this picture are Olivers, Wright's hairdressers, A. Levy & Co., The Studio and Posada, and on one of the awnings can be seen Halford Cycle Co. At Christmas, Halford's would have a large Hornby railway set laid out in their window, which would delight adults as well as children.

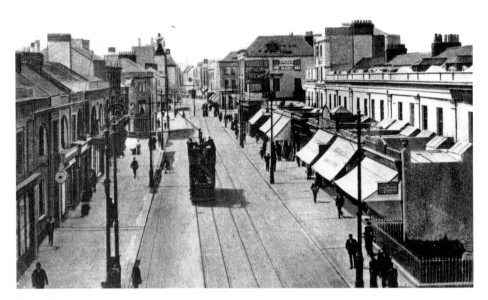

Union Street, *c.* 1905.
Famous for its public houses, Union Street became well known all over the world, mainly by the sailors who regularly frequented it. A bustling street, it contained theatres, cinemas, pawn shops, hotels and photographers as well as many general stores. The largest of the twenty or so pubs in Union Street was the Long Room, which was remembered for the barmaids all wearing long black dresses.

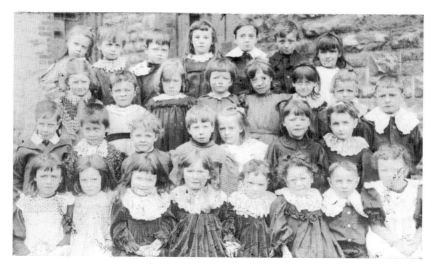

Union Street Infants' School, *c.* 1905

In the front row, in similar dresses, can be seen four sisters of the Legg family. The Union Street school was situated at Summerland Place and opened on 27 July 1883. By 1888 there were 260 male and 206 female students at the main school, with 304 children attending the infants. The headmistress of the infants' school was a Miss Mary Yeo. Union Street infants' school was bombed and destroyed during the Second World War.

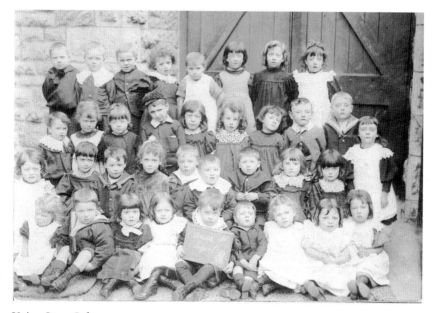

Union Street Infants, *c.* 1900

You can really get a feel for the Victorian age and its fashions from looking at this photograph. They all look shocked to be having their photograph taken! The education act of 1870 allowed for all children, for the first time, to get a proper education. Powers were given by the Government to enforce attendance of children under thirteen and school boards were elected to either levy money for fees or to decide whether to teach the children for free.

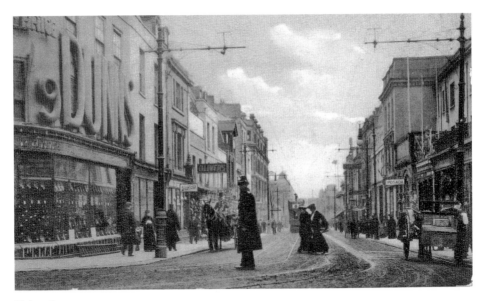

Union Street, *c.* 1910

Before traffic lights were introduced, policemen on points duty were needed to deal with the ever-increasing flow of traffic. Here, however, is a quieter time when the only traffic appears to be the odd tram and the occasional horse and cart. The photograph shows the junction of Union Street by Dunn's. In the background is Olivers, a boot and shoe shop, Wright's hairdressers, and the Posada, a popular public house that was destroyed during the war.

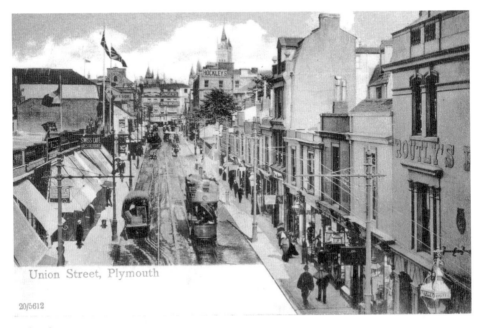

Union Street, *c.* 1910

A No. 5 tram travels along Union Street passing the Swiss Café Restaurant, which boasted that they stocked over 150 wines, both British and foreign. In the distance can be seen an advert for Singer's sewing machines. Routly's is on the right.

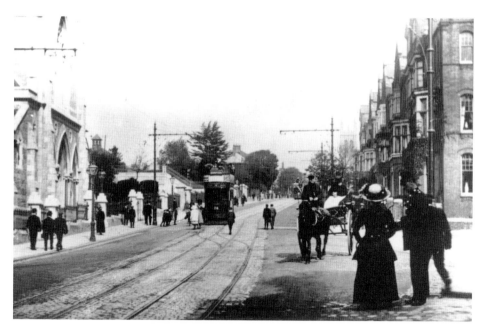

Tavistock Road, *c.* 1905

The area is still recognisable today and not much has changed apart from the disappearance of the trams and the change of fashions. Queen Anne Terrace, on the right, was once the home of professionals including doctors. It is now mainly occupied by estate agents and solicitors.

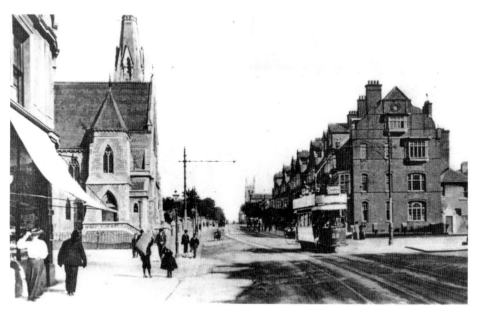

Tavistock Road, *c.* 1905

The Sherwell Congregational Chapel, on the left of the picture, still stands. It was built in 1864. On 13 January 1941, Sherwell Congregational Chapel was the first of Plymouth's churches to be seriously damaged by enemy bombing during the Second World War. The no. 26 tram is on its way to the theatre via Compton.

An Advert for Balkwill and Co. Chemists, c. 1920
Situated at 106 Old Town Street, Balkwill's were one of the West Country's
oldest chemists and stayed open twenty-four hours a day, every day. They were
specialists in fitting trusses, belts and stockings. Try getting that service from
your chemist today!

Heath & Stoneman, c. 1920
There were many opticians situated in Plymouth before the Second World War.
Heath & Stoneman were located at 24 George Street. They were established
in 1848 and a sign outside the shop read: 'Oculist's Prescriptions Dispensed
and Repairs executed in our own workshop.' They also developed and printed
photographs.

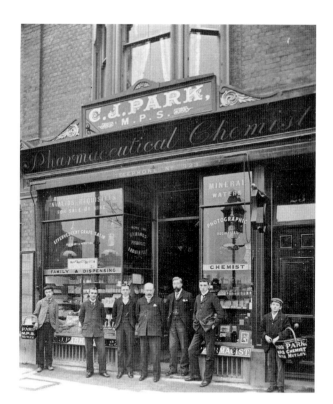

C. J. Park Pharmaceutical Chemist, c. 1905
Park's chemist was situated on Mutley Plain. Today, the the contents of C. J. Park's pharmacy are displayed in the apothecary's room at the Merchant's House, located on St Andrew's Street. Plymouth had several chemists in the town and many combined photography with dispensing drugs.

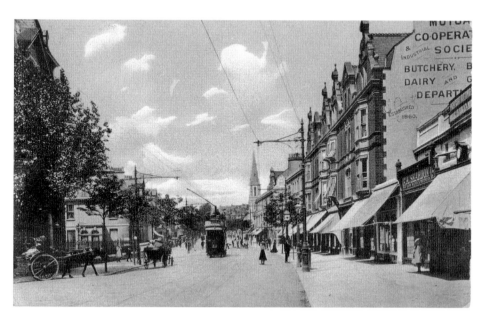

Mutley, c. 1910
Mutley comes from two words, 'gemot' and 'leah' meaning 'meeting place'. This later became 'Motte Leigh' and then finally 'Mutley'. Mutley Plain became Plymouth's secondary shopping centre after the bombing of the city in 1941. This earlier shot shows a quieter time before the two world wars.

St James the Less Church, *c.* 1912
The church stood behind the Duke of Cornwall Hotel at Clarendon Place in Citadel Road. It was consecrated in 1861 and was completed in 1879 seating a total of 600 people. Bombed in the Blitz, it was rebuilt at Ham and the old site became St Andrew's Primary School.

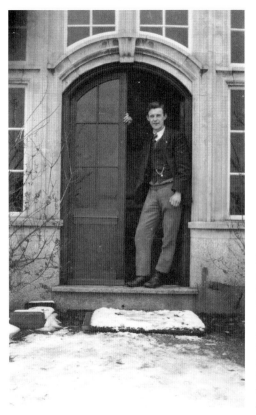

Edward Dart outside St James the Less, 1920
A school stood beside the church and was also destroyed in the Blitz of 1941. In 1868, there were sixty-two boys, fifty-two girls and forty-eight infants at the school. Teaching included the usual reading, writing and arithmetic. Geography and history were added and the girls took needlework and knitting. The boys were also taught drawing and vocal music and the ones with good singing voices were admitted to the church choir.

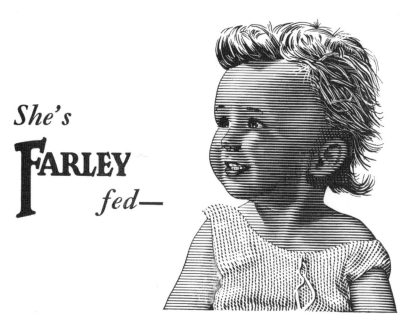

She's
FARLEY
fed—

" She's ' Farley ' fed " is a phrase one so often hears from happy mothers with contented and happy children.

Babies and young children thrive on Farley's— and what is so very important of course, is that they really enjoy their feed of Farley's from the first moment they start on " solids ".

If ever you wonder why all children love FARLEY'S you should try one yourself, they're delicious.

FARLEY'S RUSKS

— Baby's first solid food —

FARLEY'S INFANT FOOD LTD. · PLYMOUTH · DEVON

[9]

Farley's Advert, *c.* 1947
Farley's Rusks have been fed to generations of children over the years and the company name dates back to 1880. This advert is from just after the Second World War. Farley's was a very well-known business in Plymouth; it was eventually taken over by Heinz in 1994.

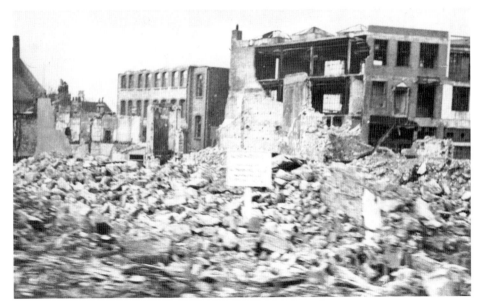

Spooner's Corner, *c.* 1941

This well-known area of the city lies devastated in this photograph taken after the Blitz of 1941. Once a popular meeting place, it had been one of the busiest road junctions in the city. A sign warns of the dangers of crumbling buildings, although it could be guaranteed that children would explore this and other bombed sites for souvenirs.

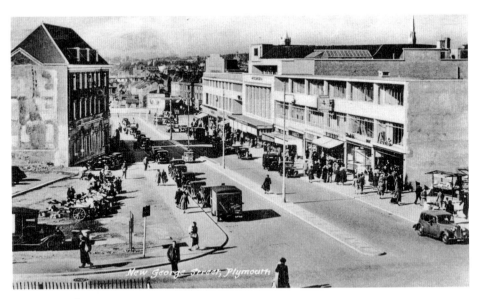

New George Street, *c.* 1949

After the war, the plan to rebuild Plymouth got underway in March 1947. New George Street, before the Blitz, would have been part of Frankfort Street. The *Western Morning News* building, Leicester Harmsworth House, can been seen on the left of the picture but the area beside, which would have been the Costers building, has been destroyed by bombing and cleared away. Opposite stood the Regent Cinema, which later became Littlewood's.

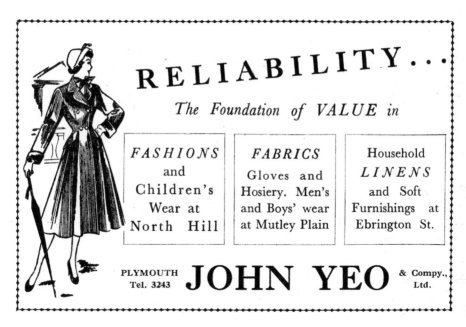

An Advert for John Yeo, *c.* 1949

John Yeo was a very well known store in Plymouth stocking a variety of fashions, fabrics and linens. After the war, both Spooner's and Yeo's moved to adjacent buildings on Royal Parade. Both buildings were later taken over by Debenham's department store.

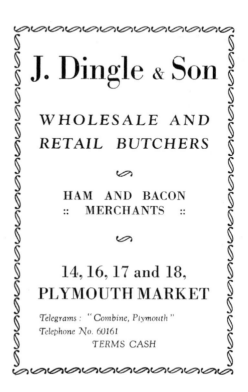

An Advert for J. Dingle & Son, *c.* 1925

J. Dingle and Son were well known butchers who were situated in Plymouth's market. After the Blitz, many major shops such as Woolworth's and Marks & Spencer were given stalls in the market so that they could carry on business as normal while the smaller market traders opened stalls in Drake Street, commonly known as 'Tin Pan Alley'.

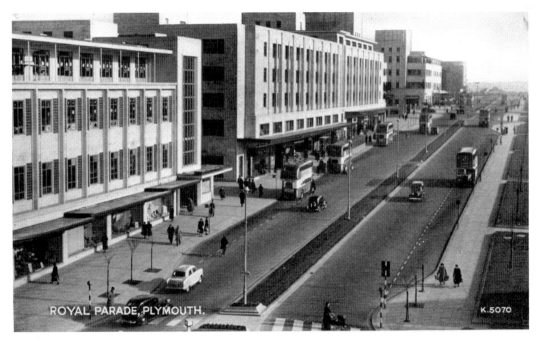

Royal Parade, *c.* 1954

More of Plymouth survived the bombing than people remember. Unfortunately, many of these buildings, although sound, were pulled down to make way for the new city centre. The modern city's main feature was Royal Parade.

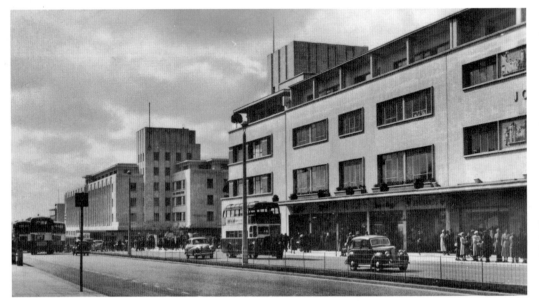

Royal Parade, *c.* 1950s

Dingle's can be seen in this photograph of the recently built Royal Parade. There was much excitement when it opened in September 1951. It was the first large store to do so in the country since the end of the war. On the far right of the picture can be seen the John Yeo building.

CHAPTER TWO

The People

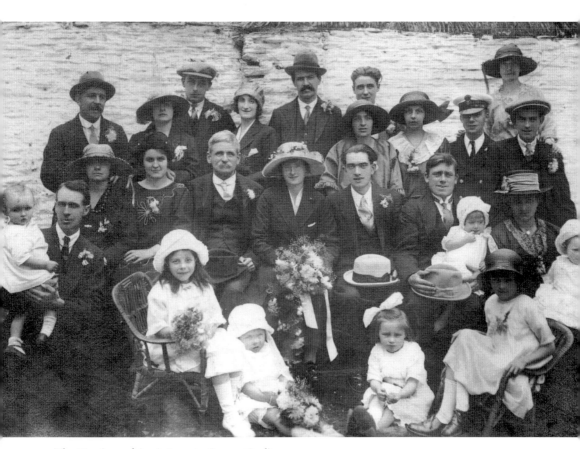

The Marriage of Annie Legg to George Gosling, 1923
It's interesting to see the fashions of the day. In the centre of the picture, with the large hat, is the bride, Annie Legg. To her left, with black hair, is the bridegroom, George Gosling. From left to right, back row: ?, Gladys Codd, ?, Bessie Perry (née Legg), Harry Codd, Jack Legg. On the far left holding his baby son, Ken, is Richard Perry, whose wife Bessie is in the back row. Also pictured, next to the bride, is Annie's grandad, Mr Legg (first name unknown).

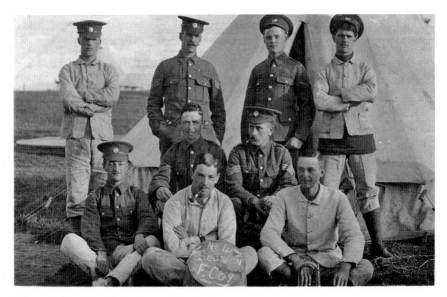

The 2nd Battalion of the Devonshire Regiment, 1912
Shown here are the soldiers of No.4 Section, 'F' Company, at Stonehouse Barracks. The photographer is Easden of Plymouth. Stonehouse Barracks still stands at the beginning of Durnford Street. Royal Marines have been stationed at the barracks since its construction in 1783.

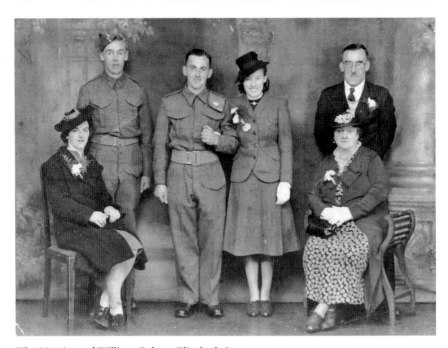

The Marriage of William Cole to Elizabeth Stewart, 1940
Left to right: Betty Cole, Frederick Stewart, Bill (William) Cole, Betty (Elizabeth) Cole (née Stewart), Sidney Stewart and Kate Stewart. Mr and Mrs Cole ran the popular grocery shop at 144 King Street for many years.

Cartes-de-Visite, *c.* 1900
Cartes-de-visite were small visiting card portraits and were introduced by Andre Disderi in 1854. During the 1860s, there was a craze for these cards and one taken of Queen Victoria and Prince Albert sold over 100,000 copies. This one was taken in George Street, Plymouth.

William Heath Studios, *c.* 1900
There were many photographic studios in Plymouth and William Heath owned one of the most popular. Located in George Street, he photographed many areas in and around Plymouth, some of which can still be found on old postcards.

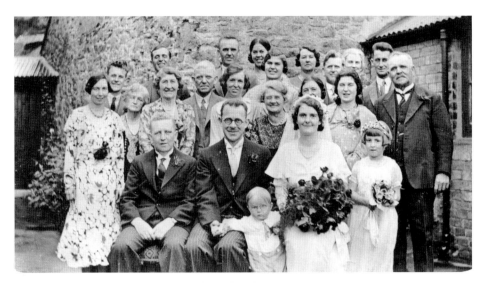

The Marriage of Phyllis Bray and Ronald Rich, July 1933
From left to right, front row: Arthur, Ronald Rich, Maurice Dart, Phyllis Bray, Myra. Next row: Mary Dart, Edward Dart, Annie Dart, Gran Rich, Ethel, ?, Marion, John Selleck, Grandad Bray. Back row: Will Liddcoat, Harold, Kathleen, Annabel, Auntie Mig, Uncle Fred, Mrs Burrows and Billy Murch.

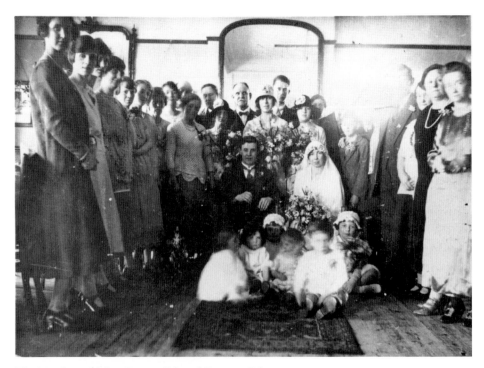

The Marriage of Mary Dart to Edward Dart, 17 February 1926
Mary and Edward Dart are featured in the middle of the picture and behind them in hats, are the three bridesmaids, Dolly, Ivy and Elsie. The fashions and cloche hats really capture the period.

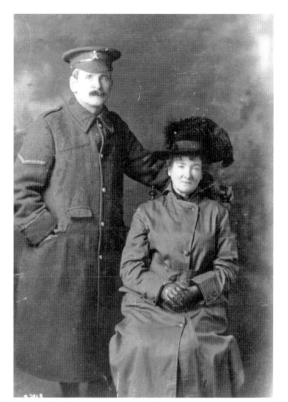

Mr and Mrs Legg, *c.* 1920
Mr Legg, a corporal, served at the Royal
Citadel looking after the horses. Work
began on the citadel in 1665 after Charles II
recognised Plymouth's important position as
a channel port. It incorporated an old fort
built in the time of Sir Francis Drake. The
cannons not only faced towards the sea but
also towards the town. This was thought to
have been to keep the town in order, as it
had supported the Parliamentarians during
the Civil War in the reign of Charles' father,
Charles I.

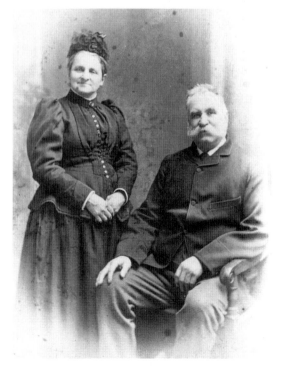

Mr and Mrs Codd, *c.* 1900
A studio photograph taken in Plymouth at
the beginning of the 1900s. Mr Codd sports
a large Victorian moustache; these were very
fashionable at the time. Although they both
wear the typically dark dress of the day, this
would probably have been their Sunday best
and only worn for special occasions, such as
having their photograph taken.

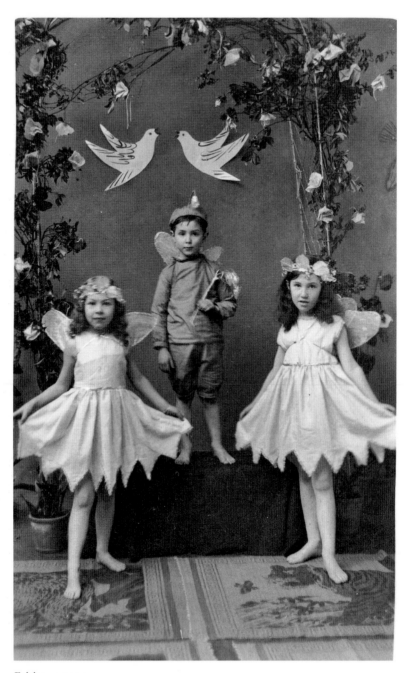

Fairies, *c.* 1910

The National Union of Teachers held their 1910 annual conference in Plymouth at the Guildhall. Local children performed a play called, *Pixie Land*. The National Union of Teachers was founded in 1869.

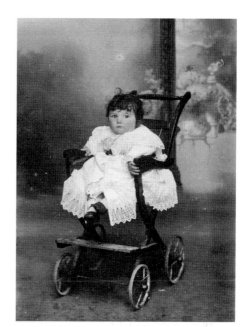

A Baby in a Pram, 1910
This shot of a baby in a very robust pushchair was taken at Elite Studios in Old Town Street. I bet she couldn't wait to get away! This contraption wouldn't have been like the comfortable prams of today and every cobble would have been felt by the sturdy, rigid wheels.

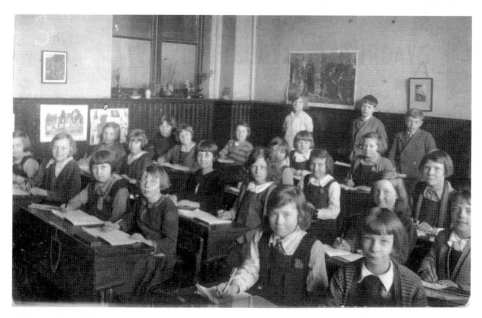

Salisbury Road School, 1931
Opened in the early 1900s, it originally had four sections: the main school, a part for deaf children, another part for 'defective' and epileptic children and finally a part for teacher–pupil instruction. It was used as a hospital during the First World War and as a billet for troops in the Second. Much was destroyed by the Blitz and the 'special' side of the school all but disappeared. Teachers there in the early days were Miss Angier, headmistress from 1903 to 1922; Miss Olivier, from 1922 to 1942; and Pauline Membrey, who had been a pupil at the school between 1928 and 1933 and returned as a teacher in 1950. Barbara Hill, with short, bobbed hair, is immediately in front of the girl in white who is standing at the back.

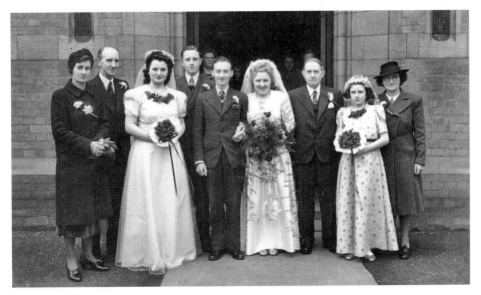

The Marriage of Eric Webb to Barbara Hill, 19 February 1944
Barbara, a Plymouth girl, worked for E. Dingle's in Bedford Street and during the war joined the WAAF (the Womens' Auxiliary Air Force). Eric worked for army intelligence in London. They first met on a train but it was another year before they saw each other again and married. Their honeymoon was spent in Richmond, Surrey, in a basement with strangers sheltering from heavy enemy bombing. They were happily married for fifty-eight years.

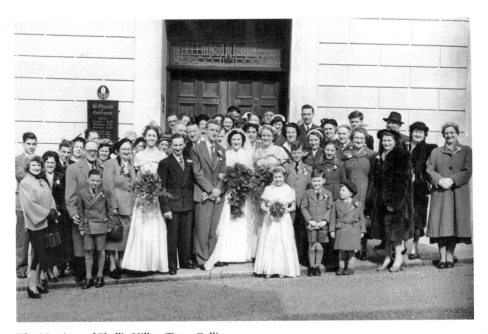

The Marriage of Phyllis Hill to Terry Collins
Eric Webb, in the pin striped suit, is best man. The ceremony took place at the church of St Edward the Confessor at Home Park Avenue, Peverell. The original church was built in 1907 but the main part of the church was built in 1935.

CHAPTER THREE

Entertainment and Outings

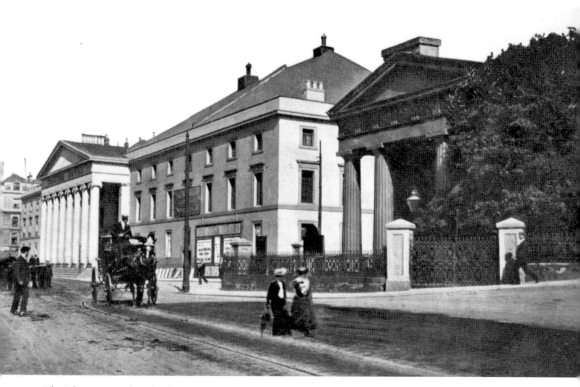

The Theatre Royal and Atheneum, 1903
The Atheneum, built in the 1800s, had to be pulled down in the 1940s after German bombing. It was later rebuilt and was opened in May 1961 but without the classic Greek columns that had made it such a feature.

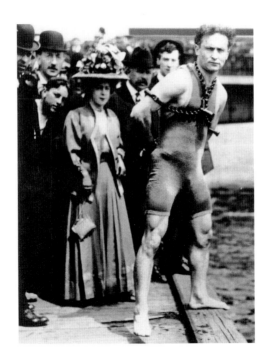

Harry Houdini, 1909

Houdini appeared at the Palace Theatre of Varieties during August 1909. There was much excitement at his appearance and he even challenged five joiners and mechanics at Devonport Dockyard to make a box from which he wouldn't be able to escape. They produced the box and Houdini was nailed inside. It took him twelve minutes to get out. Another of his daring feats involved him being securely handcuffed and diving from Halfpenny Bridge at Stonehouse. The story was covered in the next day's *Western Morning News*:

Western Morning News, Wednesday 18 August 1909.

'The Handcuff King'.
An Exciting Performance.

Harry Houdini, the 'Handcuff King', who was performing at the Palace Theatre of Varieties, Plymouth this week gave a remarkable exhibition of his skill yesterday afternoon at Stonehouse. The intrepid performer had previously announced his intention of diving from the Halfpenny Gate Bridge, securely handcuffed, and this caused a huge crowd to assemble on the bridge itself and on the adjoining quays and banks.

Prompt to time Houdini appeared, stripped and poised himself on the parapet of the bridge. He was then handcuffed with his hands behind his back, while elbow locks were also worn, the chain passing around the neck. This accomplished, he immediately dived into the stream and disappeared from sight.

Easily within the minute, the "Handcuff King" reappeared on the surface, carrying his fetters aloft in his right hand, while the crowd heartily cheered his exploit. Subsequently Houdini said that he had performed the diving trick over fifty times. He was capable of staying under water well over three minutes but should he not appear in three minutes there were always ready two or three assistants who would swim to his rescue. The handcuffs and chains weighed 18lb.

Pier Pavilion & Cafe

General Manager - - JACK MERRETT.

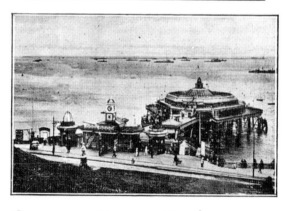

Concert Party Performances

3-15 p.m. Twice daily 7-45 p.m.

(From June 3rd onwards)

THE RIVIERA REVELS

The Super Road Show produced by Harry Benet.

NOTE REDUCED PRICES:

1/= and 6d. (including Pier Toll and Tax)

DANCING

Every Wednesday, 10 p.m. to 1 a.m. and
Saturday, 10 p.m. to 11-45 p.m.

CONCERTS EVERY SUNDAY

3-15 p.m. and 8 p.m.

CAFE OPEN DAILY

Rowing Boats on Hire AT WEST HOE PIER

For Special Attractions see Daily Papers

Pier Pavilion Advert, *c.* 1935
The pier was popular with everyone for its concert parties, winter dances and even wrestling. The popular arcade had slot machines, chocolate machines and also a 'What the Butler Saw' hand-cranked machine.

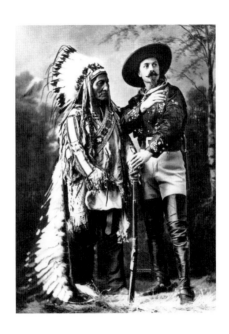

Buffalo Bill, June 1904
From the *Western Morning News* of 3 June 1904:

Buffalo Bill's Visit To Plymouth To-day.

Colonel W. F. Cody, known the world over as Buffalo Bill, gives two performances at Plymouth today in the course of his final tour of Great Britain with his unique exhibition of life in the Wild West. The location of the show at the Exhibition Fields, Pennycomequick, will make it readily accessible to residents of Plymouth, Devonport and Stonehouse, and special arrangements are being made by the railway companies to enable residents in outlying districts to witness the performance. No fewer than 800 horses participate in the show, and three special trains are employed to convey them and their properties from place to place. They arrived at Plymouth early this morning, and unloading, which occupied about two hours, began at 5:30am. This show was patronised by thousands of people yesterday, on the occasion of its first visit to Bodmin. By the addition of a number of genuine Japanese soldiers to his Wild West Show, Colonel Cody has acted only in response to a great public desire to see and learn something of these remarkable little men. Another new feature introduced is a daring leap through space by a cowboy on a bicycle. This rider starts from a height of 95 feet, and riding swiftly down an incline jumps from the incline across 40 feet of space to a continuing platform, and thence out of the arena. It is a most daring feat. The really big feature among the new things introduced by the Colonel for this season, however, is 'Custer's Last Stand' or 'The Battle of Little Big Horn'. In this, over 300 men and horses participate, giving the most realistic representation of differing methods of warfare pursued by white and red man ever attempted, and making faithful representation of the massacre of Custer and 300 members of his regiment by a band of over 7,000 Indians led by the famous old chieftain Sitting Bull, whose only son, Willie Sitting Bull is now a member of Colonel Cody's company, and is a daily participant in the mock battle. For the benefit of the country visitors, the Great Western Railway will run a late special train, which will leave Millbay at 10:55 pm calling at North Road and Mutley for Plymstock, Billacombe, Elburton Cross, Brixton Road, Steer Point and Yealmpton.

MONDAY, DEC. 10TH, 1900.	**Theatre Royal,** PLYMOUTH.

The Three Towns' = =
= **Amateur Operatic Society,**
"LES CLOCHES DE CORNEVILLE,"
IN AID OF
THE ROYAL BRITISH FEMALE ORPHAN ASYLUM, STOKE,
AND THE
G. W. RAILWAY SERVANTS WIDOWS AND ORPHANS' FUND.

Doors open 7-15 p.m. Commence 7-30.
EARLY DOORS AT 7 (6D. EXTRA.)

C. F. WILLIAMS (Theatre Royal).
CHARLES JEFFERY (Hon. Conductor).

ADMIT ONE.
UPPER CIRCLE. 2/-

A Ticket for a Performance of *Les Cloches de Corneville* at the Theatre Royal, 1901
This and the ticket below were found in an old piano, bought by Eric Webb, which turned out to
have woodworm and had to be taken apart. 'I never did learn to play the piano!' said Eric.

PUBLIC HALL, DEVONPORT.

Grand Special Performance

By ROYAL MARINE DRAMATIC COMPANY,
UNDER DISTINGUISHED PATRONAGE,
ON BEHALF OF THE
New Soldiers' and Sailors' Institute,
On THURSDAY, 7th MAY, 1903
"Black-Eyed Susan."
No. **35** RESERVED SEATS, 2/-.
Doors open at **7** p.m., Performance to
commence at **7-30** p.m. prompt.

H. L. SMITH, CLR.-SERGT., R.M.L.I
Stage and Business Manager.

A Ticket for a Performance of *Black-Eyed Susan* by the Royal Marine Dramatic Company, 1903
The marines not only played on the Hoe and in cafés in the city centre but regularly put on
performances at Stonehouse Barracks. Stonehouse Barracks housed the Globe Theatre, which was
first used in 1820. The theatre had formerly been a racquet court and hayloft.

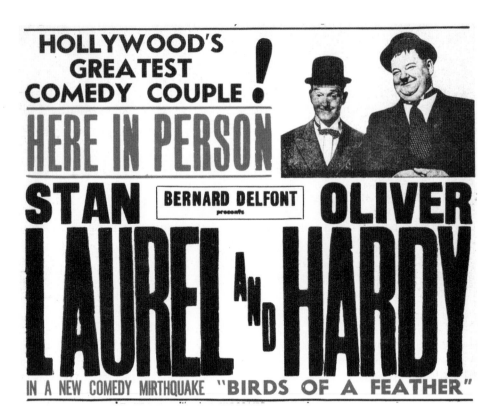

HOLLYWOOD'S GREATEST COMEDY COUPLE !

HERE IN PERSON

BERNARD DELFONT presents

STAN LAUREL AND OLIVER HARDY

IN A NEW COMEDY MIRTHQUAKE "BIRDS OF A FEATHER"

Laurel and Hardy Theatre Poster, 17 May 1954
Stan and Ollie were booked to play the last shows of their British tour at the Palace Theatre on 17 May 1954. The production was called *Birds of a Feather* and also playing on the same bill at the time were Harry Worth and 'Wonder Horse Tony'. Unfortunately, Oliver Hardy had a severe bout of the flu and also had a mild heart attack and the show was cancelled. Ollie spent the rest of his stay in Plymouth recovering at the Grand Hotel on the Hoe.

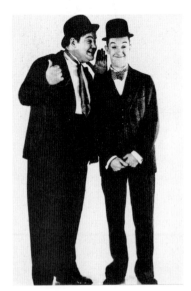

Laurel and Hardy, *c.* 1930s
Laurel and Hardy had visited Britain once before in 1932, when they were mobbed wherever they went. When they returned in 1954 they were handicapped by age and illness but still managed to give an exhausting thirteen shows a week.

48

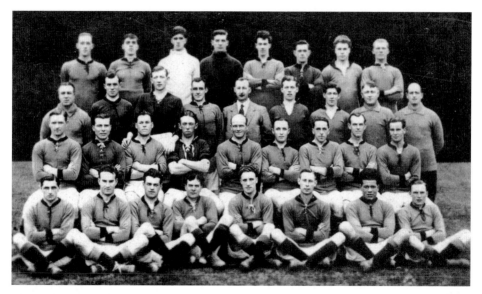

Plymouth Argyle, 1922
Back row: J. Devine, F. Cosgrove, J. Muir, W. Cook, P. Corcoran, W. Frost, J. Little, C. Miller.
Second row: F. Haynes (trainer), I. Leathlean, J. Hill, J. Logan, R. Jack, J. Jobson, C. Eastwood and S. Atterbury (assistant trainer).
Seated: J. Dickinson, B. Bowler, H. Batten, H. Kirk, M. Russell, W. Forbes, H. Raymond, W. Baker and A. Rowe.
Front row: J. Kirkpatrick, J. Fowler, J. Walker, T. Gallogley, F. Richardson, R. Jack, J. Leslie and A. Wilson.

Moses Russell, Plymouth Argyle, *c.* 1920s
Argyle played their first full game in 1886. Their captain was F. Howard Grose and the team would meet at Grose's home in Argyll Terrace. Originally called Argyle Athletic, they were named after Grose's admiration for the playing skills of the Argyll and Sutherland Highlanders regimental team. They originally only played away games as they had no pitch of their own, and their practice sessions took place at Freedom Fields. In 1901, they started playing at the ground at Home Park, which had been built for the Devonport Albion Rugby Club. In the first two years, Home Park was also the home to whippet racing and cycling tournaments. In 1903 they were allowed to join the Southern League and they then played their first official game as Plymouth Argyle.

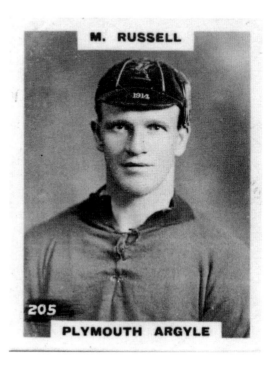

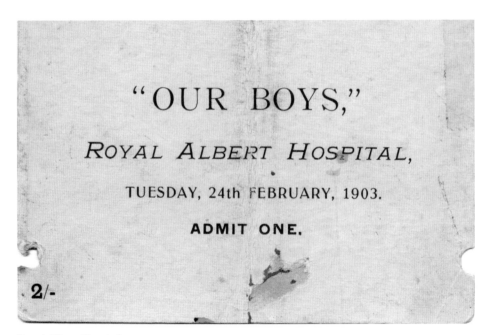

"OUR BOYS,"

ROYAL ALBERT HOSPITAL,

TUESDAY, 24th FEBRUARY, 1903.

ADMIT ONE.

2/-

Royal Albert Hospital, 1903
This ticket is for a performance of *Our Boys*. The Royal Albert Hospital in Devonport was founded in 1862. In 1918, electric lighting was installed with money raised by the nursing staff. It later became Plymouth General Hospital, but was closed in 1981 when Derriford Hospital opened. The Royal Albert Hospital was demolished in 1982.

Who's that Girl? *c.* 1920
Does this photograph remind you of Tony Curtis in *Some Like it Hot*? It's actually one Edward Dart entering a fancy dress competition in the 1920s!

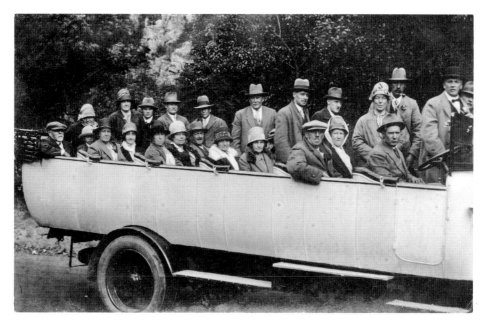

Charabanc Outing, *c.* 1920

Charabanc outings were very popular in the early 1900s. This photograph shows an outing leaving from Plymouth. Popular destinations for outings included Mount Edgcumbe Park, Cawsand, Whitsands, Burrator and Saltash Passage. Huge crowds of people would leave Plymouth for these trips in large car-like vehicles. Many of these were works outings.

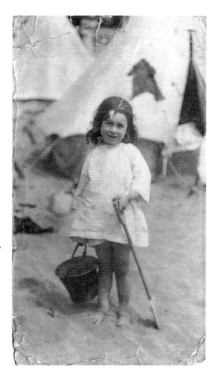

Ida with Bucket and Spade, *c.* 1910

This photograph would have been taken on a day trip to the beach, possibly at Whitsands or Cawsand. The beach was a popular destination for charabanc outings. It wasn't unusual for an outing to start at Cawsand and for the day-trippers to walk all the way to Mount Edgcumbe along the coast and through the park. There was a popular tea house in the grounds of Mount Edgcumbe Park known as Lady Emma's Cottage, and a lot of people would have eventually met up there.

Freedom Park, Greenbank, *c.* 1910

Freedom Park was the scene of a great battle on 3 December 1643 when the Roundheads fought off the Cavalier forces. A monument in the park marks the action and a plaque reads:

> Upon this spot on Sunday 3 December 1643, after hard fighting for several hours, the Roundhead garrison of Plymouth made their final rally and routed the Cavalier army which had surprised the outworks and well nigh taken the town. For many years it was the custom to celebrate the anniversary of this victory, long known as 'The Sabbath Day Fight', and recorded as 'The Great Deliverance' of the protracted seige, successfully sustained by troops and townsfolk on behalf of the Parliament against the King under great hardships for more than three years.

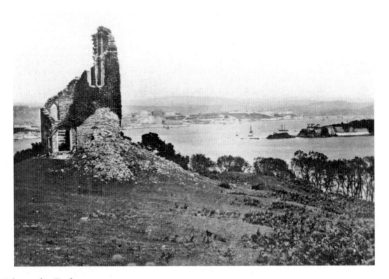

Mount Edgcumbe Park, *c.* 1905

The folly has always looked like this and isn't a ruin that has collapsed over the years. It was originally built in the early 1700s from the remains of two old Stonehouse chapels. An artist painting the scene at the end of the 1800s wrote that the Earl of Mount Edgcumbe had his workers build a folly, had it blown up, didn't like the result, and had it built and blown up again to get today's result.

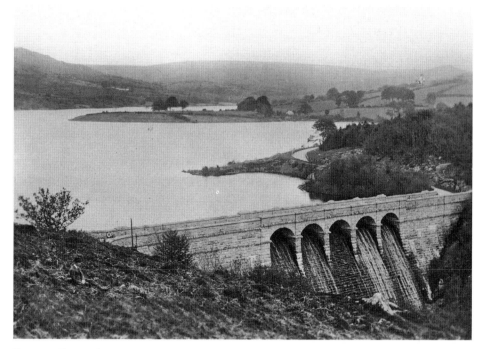

Burrator Reservoir, *c.* 1920s

Work started on the dam in 1893 and it was officially opened by the Mayor, J. T. Bond, in 1898. The total cost was £178,000. The dams at Burrator and Sheepstor were raised by 10 feet in 1923, which allowed the reservoir to hold a capacity of 1,026 million gallons. A suspension bridge was erected at the dam to carry works traffic. The work was completed in 1928.

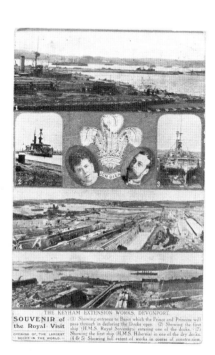

Royal Visit to the Keyham Extension Works at Devonport Dockyard, 1907

This card is a souvenir of the royal visit which celebrated the opening of the largest dock in the world at the time – the Keyham extension works at Devonport. The North Yard extension was the final phase of the Royal Dockyard and work began in 1896. Its first ship, HMS *Hibernia*, had docked there in 1906 prior to the official opening. The total cost was £6 million.

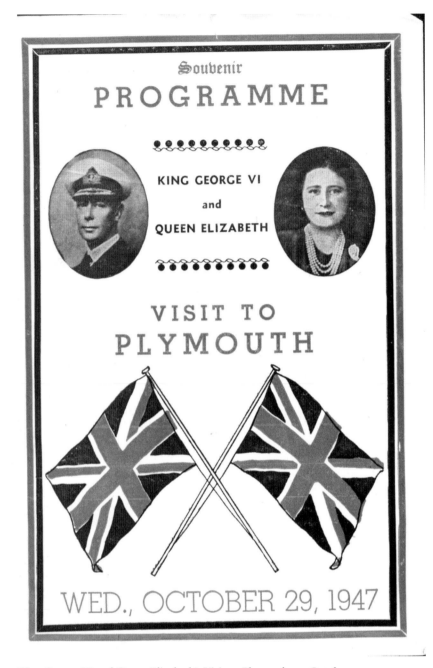

King George VI and Queen Elizabeth's Visit to Plymouth, 29 October 1947
The King and Queen visited Plymouth to give a royal inauguration to the rebuilding of Plymouth's city centre, which was destroyed by enemy action. Thousands of people turned out to see them. Royal Parade was built at a cost of £180,000. The western end of Royal Parade from Courtenay Street to Westwell Street was opened to coincide with the royal visit, and the remaining part was completed on 27 September 1948.

Millbay Docks and Laira Wharf

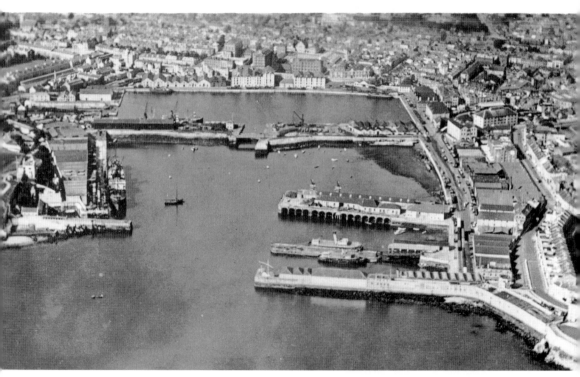

An Aerial Shot of Millbay Docks, *c.* 1930s
Built to plans by Isambard Kingdom Brunel, the dock cost a total of £250,000 and was completed in the 1840s. It was a major port until 1939 and sometimes received over 600 ocean liners a year.

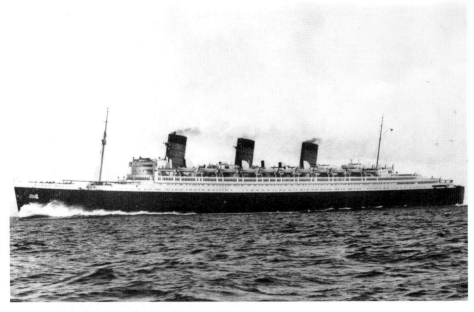

The *Queen Mary*, *c*. 1930s
Plymothians would line the docks in the hope of seeing famous passengers disembark from the many ocean liners that moored at Millbay Docks. The *Queen Mary* was Cunard's pride and joy. Famous passengers who docked at Plymouth on the *Queen Mary* included Gloria Swanson and Jack Warner who both arrived in the city in 1938.

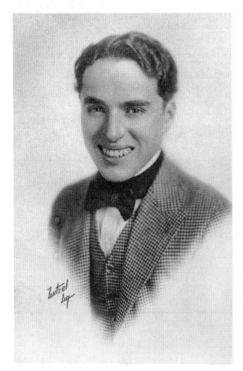

Charlie Chaplin, *c*. 1930s
Charlie Chaplin disembarked from the *Mauretania* in 1931 to the delight of many Plymothians that had come to see him. He was the star of many silent films and made *City Lights* in the same year. The *Mauretania* made its final eastwards crossing on September 1934, from New York to Southampton, and was sent to the breaker's yard in July 1935.

A Ferryman, *c.* 1910
The great ocean liners would moor in the Sound or off Cawsand Bay and their passengers would be taken ashore by the ferrymen and their tenders, *Sir Richard Grenville* and *Sir Francis Drake*. The *Sir Richard Grenville* was built in 1931. It was the second tender boat to be given this name, the original being built in 1891. Both were owned by the Great Western Railway, although in 1947, the second *Sir Richard Granville* was transferred to the British Transport Commission. It was withdrawn from service in 1963.

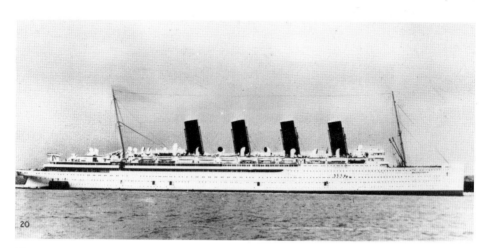

The *Mauretania*, *c.* 1930s
The *Mauretania* came to Plymouth regularly and delivered passengers and mail to the city. Film stars were quite often amongst the passengers, one of these being American crooner Bing Crosby. The *Mauretania* was built by Swan, Hunter & Wigham in Newcastle in 1907. It was the world's fastest liner from 1907 to 1927 and was part of the Cunard Line's Liverpool to New York service.

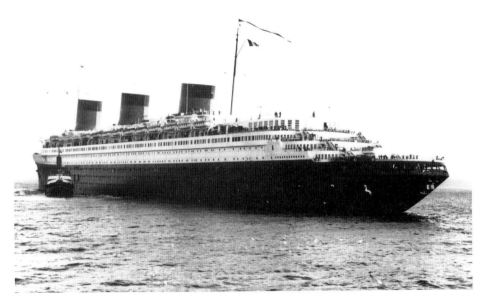

The *Normandie*, c. 1937

The *Normandie* steamed into Plymouth Sound in 1937 after crossing the Atlantic in a record breaking time. The *Normandie* was the industry's first 1,000 foot ocean liner. Walt Disney was among the many famous passengers who landed at Plymouth. The liner capsized and caught fire in New York while being converted for use in the Second World War. This picture of the liner was taken in Cawsand Bay, just off Plymouth.

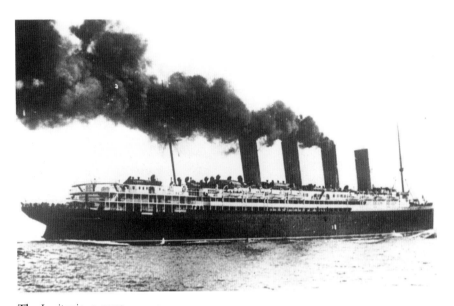

The *Lusitania*, c. 1910

The *Lusitania* was a regular visitor to Plymouth and would take emigrants all over the world. The *Lusitania* was torpedoed by a German U-Boat in 1915 with a loss of 1,195 lives. The Captain was thrown clear and survived the tragedy.

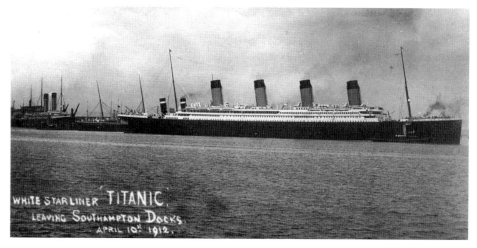

WHITE STARLINER TITANIC,
LEAVING SOUTHAMPTON DOCKS.
APRIL 10ᵗᴴ 1912.

The *Titanic*, 1912

On 28 April 1912, the *Titanic* survivors were brought back to Millbay Docks, fourteen days after the ship had sank. At 8 a.m., the SS *Lapland* moored at Cawsand Bay with the 167 members of the *Titanic* who hadn't been detained in New York for the American inquiry. Three tenders left Millbay Docks to collect the passengers and the 1,927 sacks of mail that had been scheduled to be carried by the *Titanic*. The third tender, the *Sir Richard Grenville*, carrying the survivors, killed time in the Sound while the dock labourers and porters were paid off and escorted out of the dock gates at West Hoe. After midday, the tender was given the all-clear and the survivors were allowed to disembark in an air of secrecy. They were then put on a special train from Millbay Docks to Southampton, where they arrived at 10.10 p.m. that night.

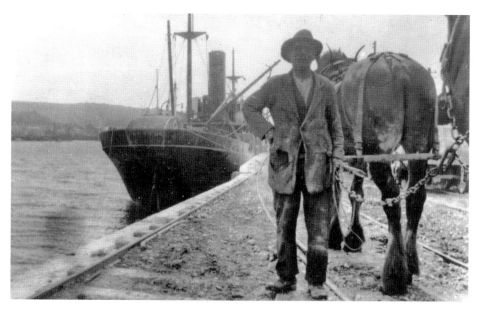

Harry Osbourne and his Wagon at Laira Wharf, *c.* 1915

The china clay industry has been in existence for over 250 years and clay has been mined at Lee Moor for over 180 years. The clay at Lee Moor would be brought down to Laira Wharf by horse and cart to be loaded on to the many boats waiting there to take it worldwide.

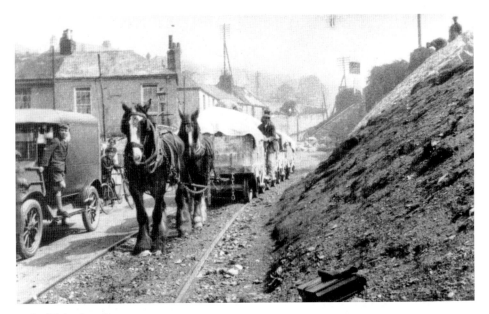

End of Laira Junction, *c.* 1930s

Here we see china clay on its way from Lee Moor to Laira Wharf. There were sometimes up to a dozen trucks a day pulled by horses down to the wharf. Look at the boys' excitement to see the horses and trucks go by. The Lee Moor tramway was opened in 1858 but fell into disuse in 1939 and the track was taken up in 1961.

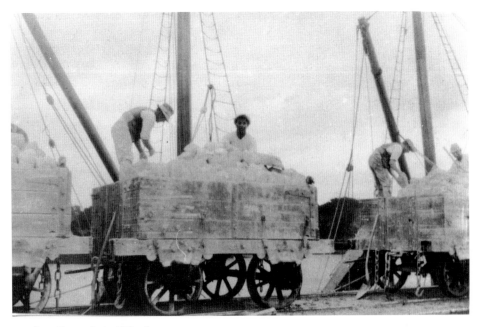

Loading Clay at Laira Wharf, *c.* 1930s

Here, clay casks are being unloaded from wagons to be sorted and shipped worldwide. The first use of clay in the west of England was for the manufacture of porcelain. It is also now used in paint, cement, in the plastics and rubber industries, and various other products.

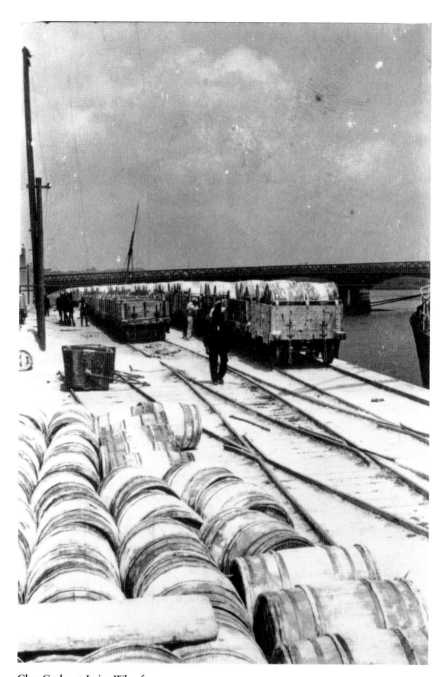

Clay Casks at Laira Wharf, c. 1930s
China clay has been worked in south west Dartmoor since 1830. Many settlements at Lee Moor and Wotter only exist because of clay working. Arthur Bray can be seen in this picture. Notice how the track and wharf have been turned white by clay deposits.

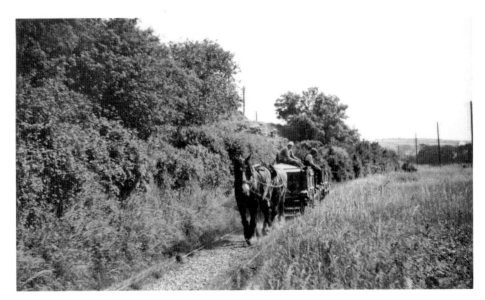

Lee Moor Tramway Southbound, *c.* 1950.

The Lee Moor tramway crossed the Great Western Railway line at Laira and, being an older route, the horse-drawn trucks took precedence over the trains. It was quite a journey from Lee Moor to Laira Wharf and the horses would have been well cared for and looked after as they would have to make this journey several times a day.

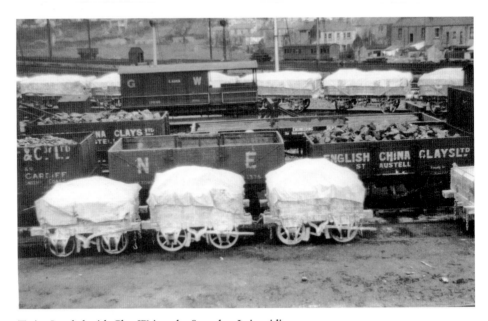

Trains Loaded with Clay Wait to be Sorted at Laira sidings, *c.* 1950

The eighteenth and nineteenth centuries saw a vast improvement of access from the moor with the development of tramways and railways. When China clay, or Kaolin, was discovered in England, it was found to be a far superior quality to that of its counterparts in Europe. William Cooksworthy made the discovery of china clay at Tregonning Hill, near Helston, in 1746, and took out a patent to use it in 1768 to produce porcelain at his Plymouth factory.

Laira Wharf, *c.* 1910
This photograph shows John Bray Junior and German clay-boat-captain Shelstroom.
By 1910, almost a million tons of china clay a year was being produced and paper
had become its prime use. Three quarters of the output was shipped abroad to North
America and Europe.

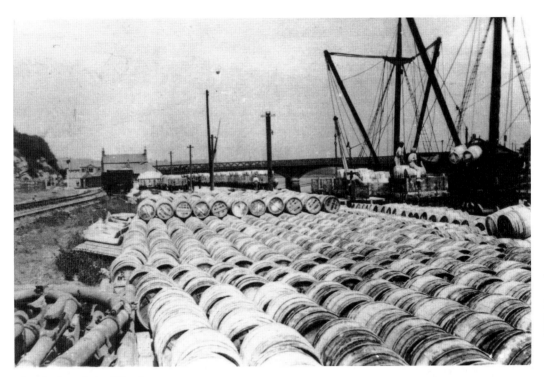

Clay Casks at Laira Wharf, *c.* 1930s

Clay production expanded greatly between 1950 and 1970 with a rising demand for clay from paper manufacturers worldwide. The value of clay sold to date, at today's prices, is a staggering £13.5 billion. This compares with the amount of tin and copper sold which works out to a total of about £9 billion.

CHAPTER FIVE

The Barbican and the Hoe

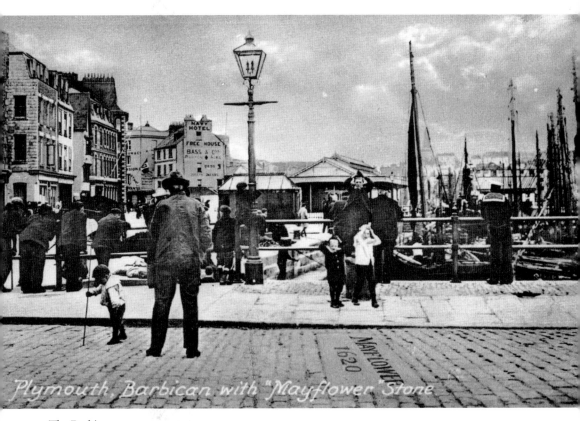

The Barbican, *c.* 1905
In the foreground can be seen the *Mayflower* Stone, the point where the Pilgrim Fathers were said to have left from in 1620. However, at that time the water would have come much further inland and the actual leaving point is said to be where the ladies' toilet stands in the Admiral McBride public house. Try telling that to an American tourist.

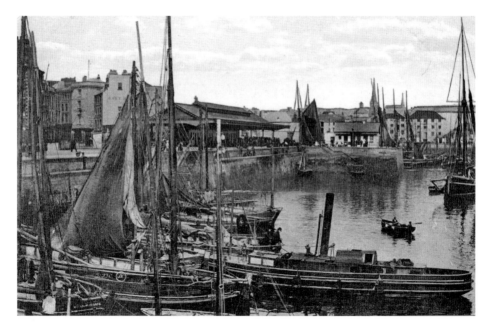

Sutton Harbour, *c.* 1910

The city of Plymouth has its origins around Sutton Harbour and the first dwellings in the town appeared there. The Anglo Saxon invaders landed there in AD 700. Sutton means 'south farm' in Anglo-Saxon. At the pool entrance, there are two piers, built in 1791 and 1799 respectively, which were constructed to make the pool safe from tides.

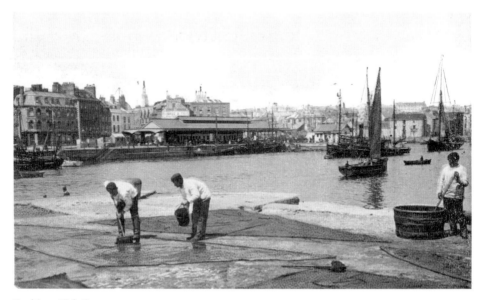

Barbican Fish Quay, *c.* 1905

At the end of the 1800s, over 300 fishing boats could be seen in the harbour with 500 handcarts waiting for their catch. By 1890, more than 5,000 tons of fish would leave the area to be sent by rail to other parts of the country.

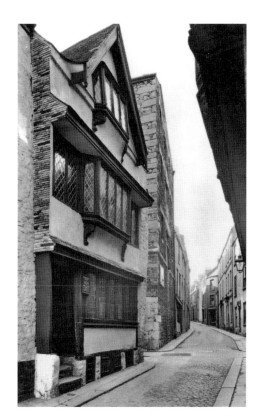

New Street, *c.* 1920
The Elizabethan House in New Street dates from 1584 and is a restored captain's dwelling. It's not hard to imagine Walter Raleigh, Francis Drake, John Hawkins or Captain Cook wandering down the narrow cobbled streets here.

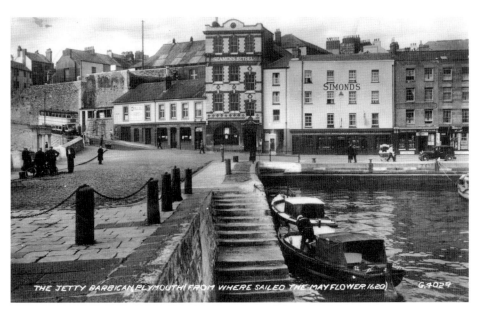

The Barbican, *c.* 1930s
The Barbican was originally known as Watergate and was once part of a castle that defended the entrance to Sutton Pool. All that remains of the original castle is part of a wall at Lambhay Street.

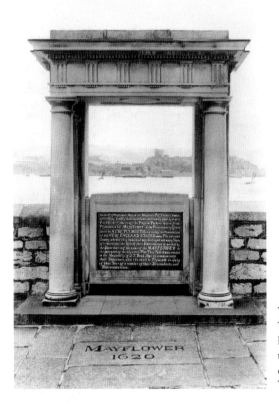

The *Mayflower* Memorial, *c.* 1940
The *Mayflower* Memorial and canopy were built in 1934 to commemorate the sailing of the Pilgrim Fathers to the New World. It was designed by J. Wibberley at a cost of £239. The memorial tablet dates from 1891.

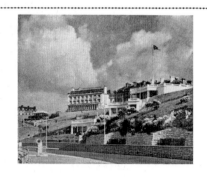

The Grand Hotel, *c.* 1950.
The hotel was built by John Pethick in 1879 and he also became the first owner. At the time, the Grand was the only hotel in Plymouth with a sea view and adverts stated that it had the finest view in Europe.

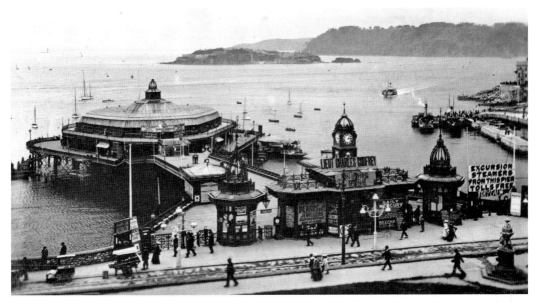

The Pier, *c.* 1887
The pier was opened in 1884 and cost £45,000 to build. It attracted huge crowds who came to either take a stroll on its decks or to attend dances or concerts. There were also regular skating sessions and boxing in the pavilion. It was destroyed in the Blitz of 1941 and the last remains of it were removed in 1953.

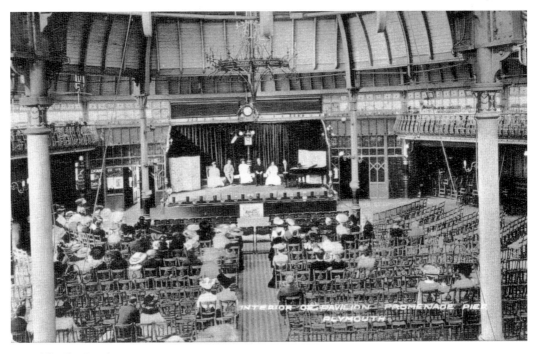

The Pier Interior, *c.* 1905
All manner of shows were held at the pier. In the winter there were regular concerts and in the summer there was wrestling, dancing and performances on Sundays by the Royal Marines band.

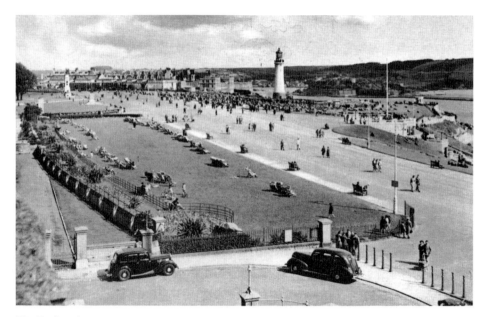

The Esplanade, *c.* 1940s
This view of the Esplanade has been taken from the Grand Hotel. In the foreground, you can see a few early cars. In the background are the Citadel and the aquarium, with views stretching towards Mount Batten. Note that Smeaton's Tower was painted white at the time. It has now been painted in its original red and white striped paint scheme but has endured some unusual colours over the years!

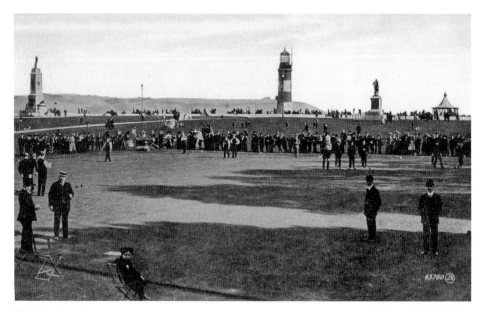

The Bowling Green, *c.* 1910
Francis Drake was said to have spotted the Spanish Armada from here while playing bowls. However, the green didn't exist at the time and Drake would have actually played bowls in a different location, possibly on the land where the Citadel stands today.

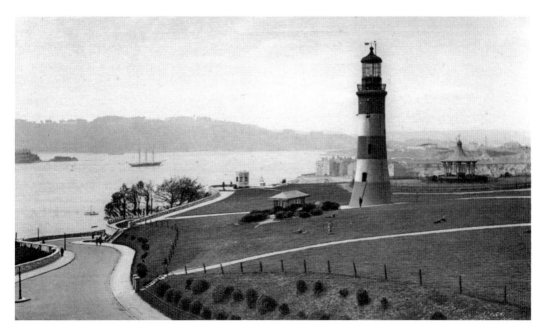

Plymouth Hoe, *c.* 1930s
The Hoe is dominated by Smeaton's Tower, which lit the channel fifteen miles off Plymouth's shore for 123 years before its removal to Plymouth Hoe. It has been a landmark on Plymouth Hoe for over 100 years and attracts thousands of visitors.

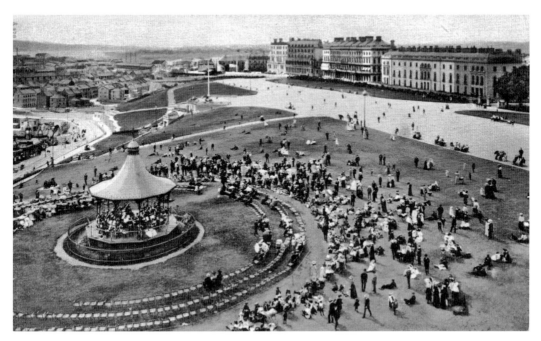

The Marines Band Playing on the Hoe, *c.* 1905
Huge crowds would gather to hear the Royal Marines Band play on the Hoe. The bandstand was dismantled during the Second World War and unfortunately never replaced.

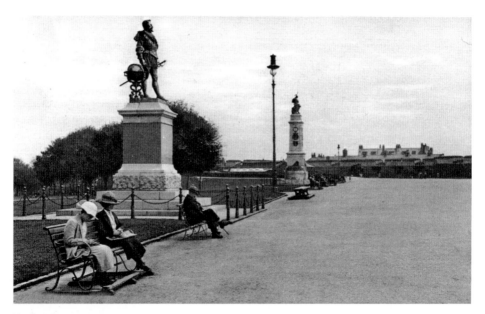

Drake's Statue, *c.* 1920s
Drake looks out to the Sound from probably the best vantage point he's ever had to see the invading Armada! The statue is a duplicate of the one that stands on the approach to Tavistock, Drake's birthplace.

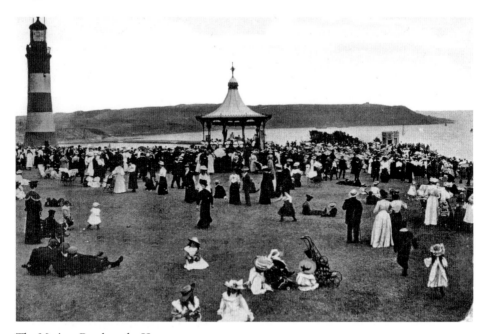

The Marines Band on the Hoe, *c.* 1905
This early scene shows the bandstand in the middle of the picture. To the right is a building very often thought to be the old camera obscura. However, the actual obscura building was located further back along the esplanade just above the Belvedere. People would form large queues at the obscura to see the spectacular all round view that was projected there. It lasted from about 1860 to 1890.

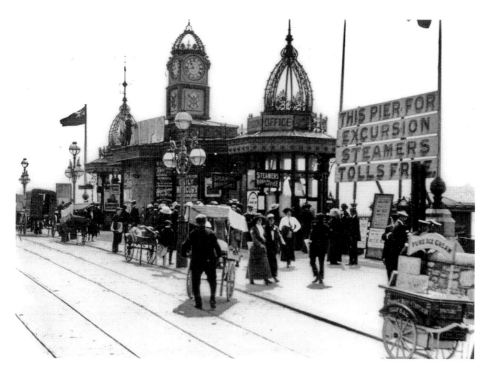

The Pier, c. 1887

The pier was officially opened on 25 May 1884. The Mayor, John Greenway, was presented with a silver-gilt key to unlock the gate. About 30,000 people attended the ceremony of which 10,000 were on the pier. Unfortunately, by 1922, interest in the pier had waned and some of the passenger steamers that cruised the Sound and the Tamar were sold off. By 1938, after continuing losses, the receiver was called in and there were discussions about what to do with the pier. An attempt to sell it to the city council failed but the problem was solved by the Blitz of 1941.

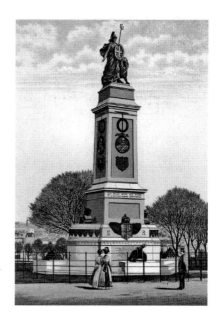

The Armada Memorial

The foundation stone for the memorial was laid in 1888 which would have been the 300th anniversary of the first sighting of the Spanish Armada. The statue at the top of the pedestal is a bronze figure of Britannia. It was unveiled on 21 October 1890 by the then Duke of Edinburgh.

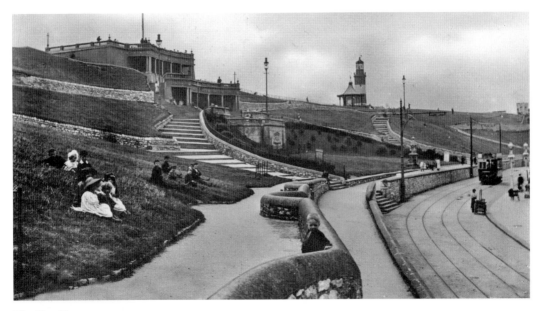

The Hoe Slopes, *c.* 1910
This scene looks much the same today, although a tram follows the road, probably stopping at the pier. It's interesting to see the children of the time sat on the bank; most are wearing hats.

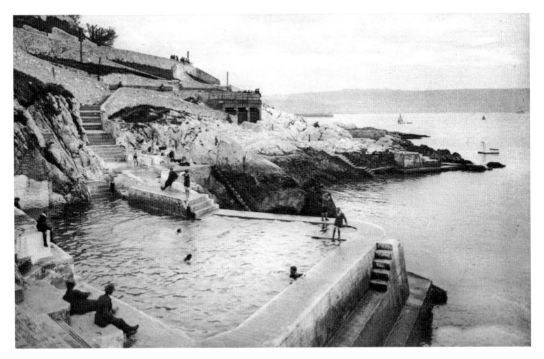

The Men's Pool, *c.* 1920s
In 1860, all-day swimming was allowed, but, as was reported in the local newspaper, 'dead cats and sewerage spoiled it'. In 1877, a ladies' pool was opened west of Tinside and in 1907, a men's pool opened adjacent to the pier. In 1919, mixed bathing was allowed.

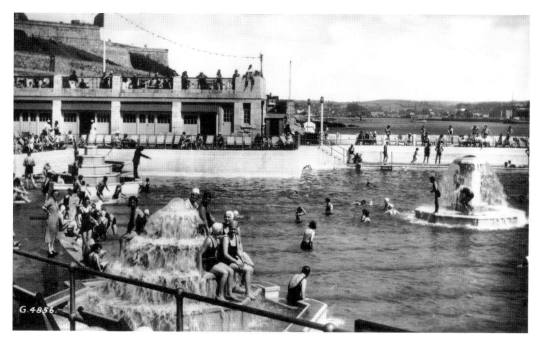

The Lido at Tinside, *c.* 1930s
The pool was opened on 15 June 1933. It was an important occasion and thousands of people turned up to witness the event. At the time, the art deco pool was a spectacular sight with three fountains to aerate the water and at night, floodlighting from below.

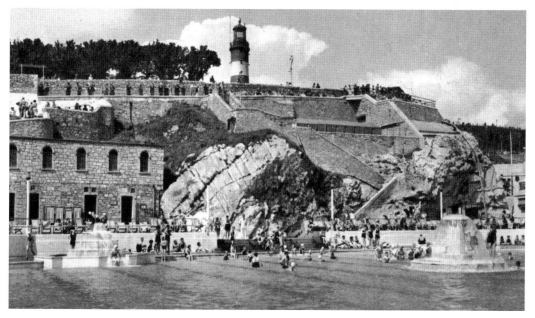

The Lido, *c.* 1938
The Lido has been a popular attraction for adults and children for many years. Allowed to fall into disrepair in recent times, the Lido has now been refurbished and is ready to welcome many future generations.

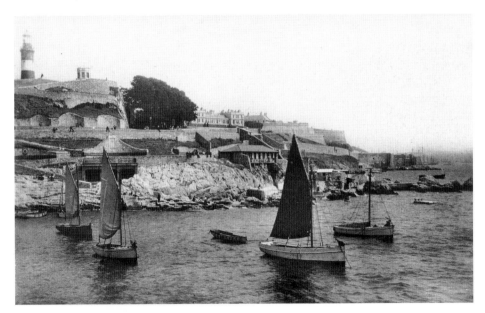

Boats in the Sound, *c.* 1910

This view, taken from the pier, shows the many small boats that occupied the Sound at the time. The Sound was a busy place for sailing craft. Many fishing boats would leave from the Barbican and pass this way. There would also be pleasure boats, ocean liners and Navy warships occupying the waters.

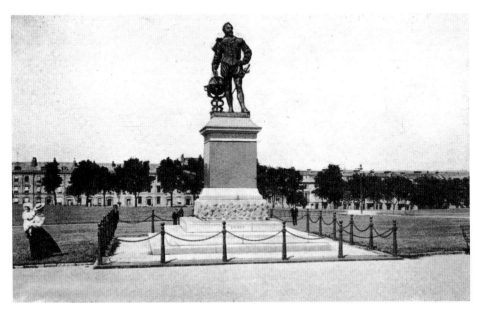

Drake's Statue, *c.* 1910

The statue was unveiled by Lady Elliot Drake, a descendant of Drake, in front of 20,000 people on 14 February 1884. The day was observed in the three towns as a holiday. The sculptor was criticised for making Drake too handsome, too tall and for more resembling Drake's friend, Sir John Hawkins.

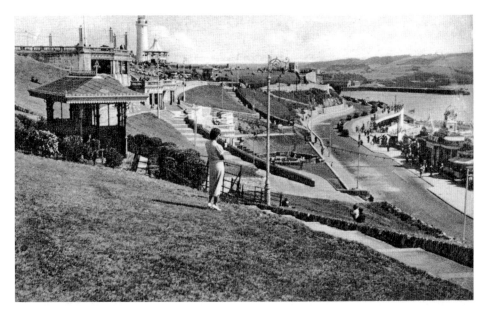

The Hoe Slopes, *c.* 1930s
'Hoe' is the Anglo-Saxon word for 'high place'. This pre-war shot shows the pier, and on the road, cars have replaced horses and carts. The trams have also disappeared and been replaced by buses.

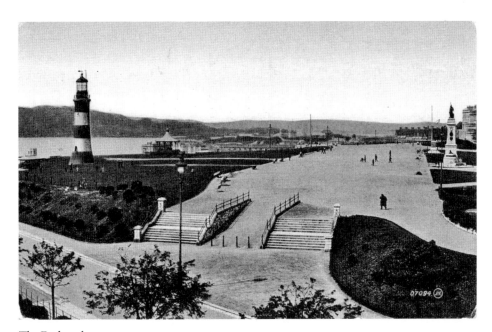

The Esplanade, *c.* 1915
This view, taken from near to the aquarium, stretches over the Esplanade to West Hoe in the background. Smeaton's Tower and the bandstand can be seen on the left of the picture and the Armada Memorial can be seen on the right.

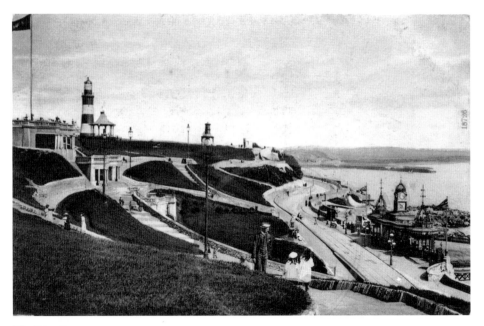

The Hoe Slopes, *c.* 1910

This photograph shows an early shot of the Hoe slopes. Notice the man wearing a boater with his two little girls probably on their way to stroll the boards or to play the arcade machines on the pier. The foreshore was developed in 1913.

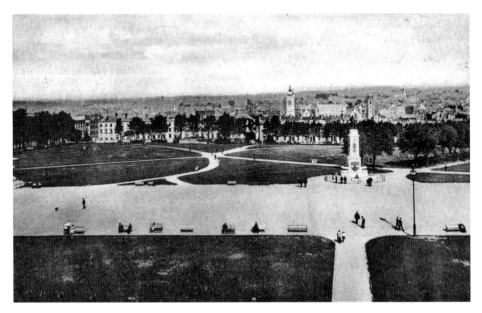

The View from Smeaton's Tower over the City, *c.* 1920

This view shows the city before it was heavily bombed in 1941. The Guildhall and St Andrew's church are easily visible. The monument in the picture is the Armada Memorial. It was designed by Herbert Gribble of London and incorporates a bust of Sir Francis Drake and the inscription, 'England expects that every man will do his duty'.

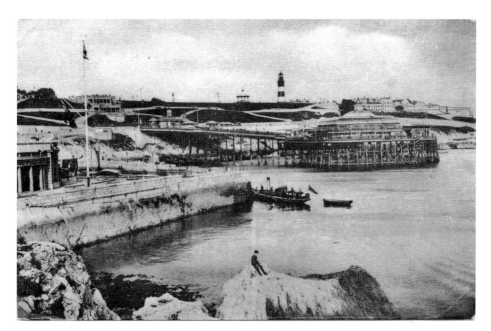

The View from West Hoe, *c.* 1905
This photograph shows the view looking back towards the Hoe from West Hoe. A pleasure boat can be seen leaving the jetty, probably for a trip up the River Tamar. The Citadel can be seen in the background. This photograph also shows the pier stretching out into the Sound.

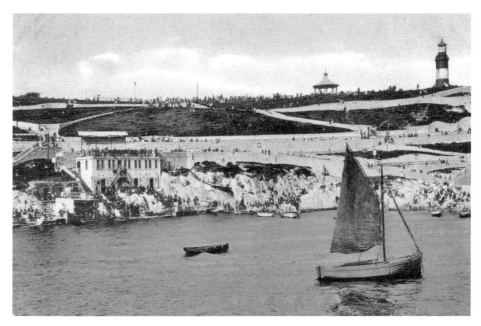

Bathing Place, the Hoe, *c.* 1910
Visitors line the top of the Hoe to watch the Plymouth Regatta which was held annually and attracted thousands of people. Regular swimming contests on the Hoe would also draw large crowds.

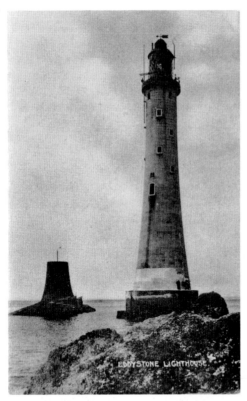

Eddystone Lighthouse, *c.* **1910**
This was the fourth Eddystone Lighthouse to be built. The first two lighthouses had been built of wood. The first, built in 1698, was washed out to sea, taking its architect, Winstanley, with it. The second, built by Rudyerd in 1706, caught alight and was completely destroyed. John Smeaton began work on the third lighthouse, to be built completely out of stone, in 1756. When the Eddystone lighthouse was replaced by one built by James Douglass in 1877, Smeaton's Tower was removed block by block and rebuilt on the Hoe. The stump where Smeaton's Tower once stood can still be seen alongside the current lighthouse.

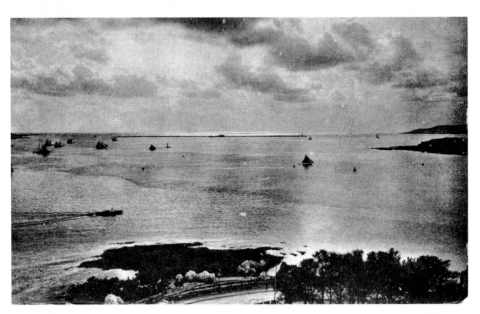

Plymouth Sound, *c.* **1905**
Not too much has changed in this view since Sir Francis Drake's time, although the Sound has seen many nautical events since, such as Sir Francis Chichester returning home from his round-the-world voyage in 1967.

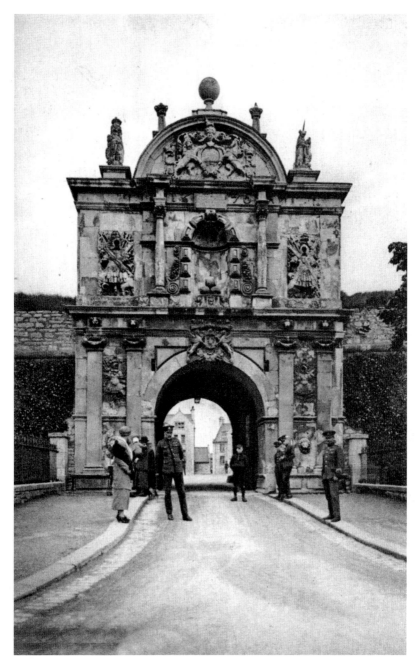

The Citadel Gate, *c.* 1920s

Built in 1670, the gate still stands today, although there was once a drawbridge and a moat. The moat was removed in 1888. There was also once a statue of Charles II where the cannonballs now stand.

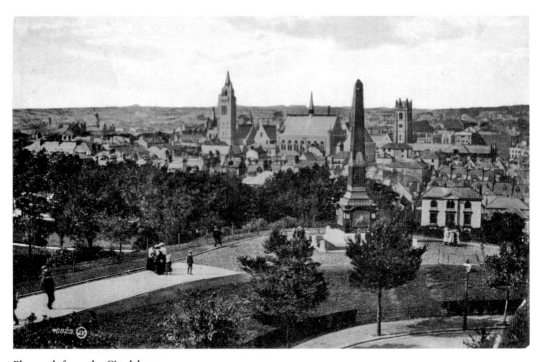

Plymouth from the Citadel, *c.* 1910
In the foreground is the South African War Memorial. It was unveiled on 8 August 1903 by Lady Audrey Buller and commemorates the regiments that fell during the Boer War of 1899 to 1902.

CHAPTER SIX

Transport

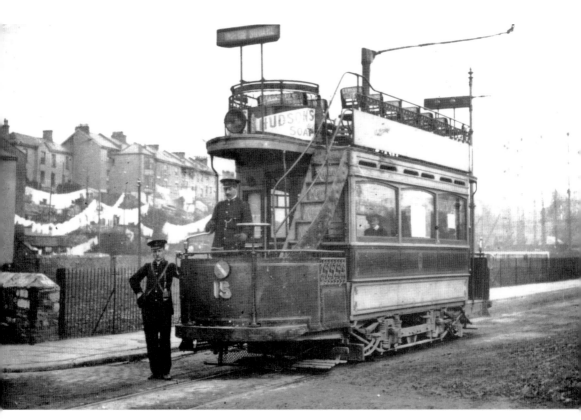

Car No. 15, Devonport, *c.* 1909
The tram is pictured in St Levan's Road with the gasometers behind. The Three Towns' first tramway was opened in 1872. It ran from Derry's Clock in Plymouth, through Union Street, across Stonehouse toll bridge, and as far as Cumberland Gardens in Devonport.

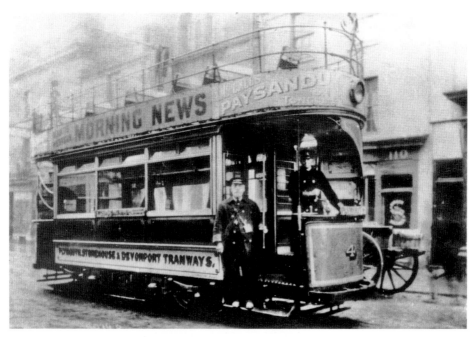

Car No. 4 at the Stonehouse End of Union Street, *c.* 1910
This tram belonged to the Plymouth, Stonehouse & Devonport Tramways, a company that ran between 1901 and 1922. At the time, they had a fleet of sixteen electric trams. This one, No. 4, is brightly decorated with adverts, including one for the *Western Morning News*.

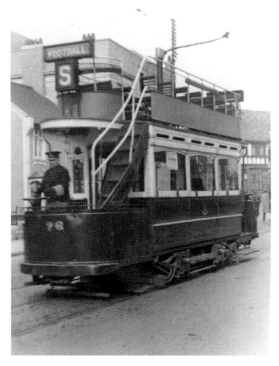

A Devonport and district tram built by Brill, *c.* 1929
This tram was a 'special' and its destination is given as 'Football'. Argyle would have been playing at home nearby. It is pictured at Milehouse on its way to Fore Street. In the background, you can just see the Britannia public house.

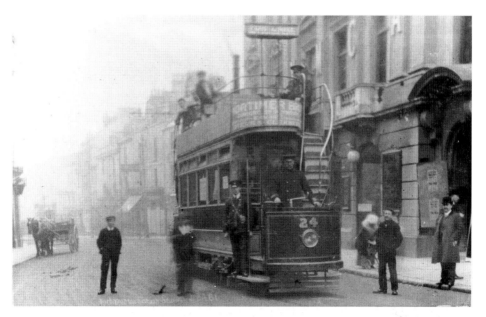

No. 24 Tram, Fore Street, Devonport, *c.* 1910
Devonport got its own electric tram service in 1901, a long time after it was promised one in 1882. Fore Street would have been the main shopping centre in Devonport at the time, with over 100 businesses stretching from the Dock Gates to Granby Barracks. These included Woolworth's, Timothy Whites, Liptons, Boots, British Home Stores and Marks & Spencers. This tram has an advert for Mortimer Brothers that reads, 'Dyers and Cleaners'. On the left of the picture can be seen a horse and cart as well as something the horse has left behind!

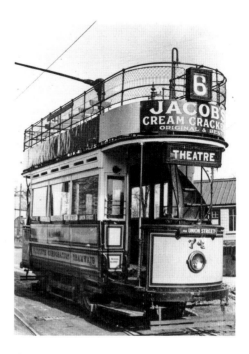

A Tram at Stonehouse, *c.* 1930s
Part of the Plymouth Corporation Tramways, this tram's destination would have been 'Theatre' via Union Street from Devonport – one of the most used lines in Plymouth. On its side are its destinations, including North Road and Fore Street. This one features an advert for Jacob's Cream Crackers.

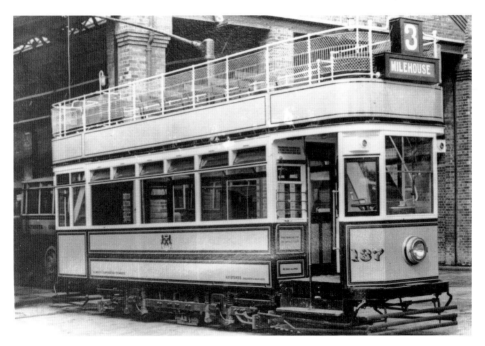

The No. 137 Tram at Milehouse Depot, *c.* 1938
Known as a 'Squareface' model, this tram would have been painted yellow. It is pictured at the back of the Milehouse sheds. Trams suffered a lot of wear and tear and had to be maintained regularly. They also had to be updated to comply with the strict safety regulations of the time.

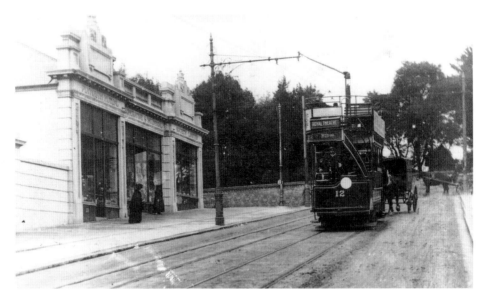

The No. 12 Tram at Peverell Tramway Terminus, *c.* 1909
This tram is travelling down Peverell Park Road towards the Royal Theatre. A horse and buggy follow very close behind, probably heading for the same destination. It wasn't until 1899 that the Tramways Department opened its first electric tram service. On the left of this picture can be seen the Plymouth Mutual Co-operative & Industrial Society building.

A Tram Token, *c.* 1930s

Shown here is a Plymouth Corporation token, which could be used on any of the trams or buses within the area, this one is for 1*d*. Trams had been powered by various means, the most well known were the horse-drawn trams and the later electric ones. However, in 1882, the Plymouth, Devonport & District Tramways Company wanted to build an extensive steam tramway system. The borough of Devonport objected to the lines being open and run in Plymouth before they had been completed in Devonport. A service started on the 3 November 1884 but ended on 14 November 1884 after the Devonport Corporation obtained an injuction to halt the service.

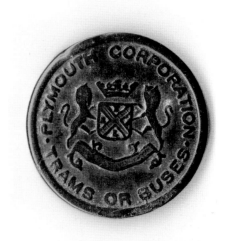

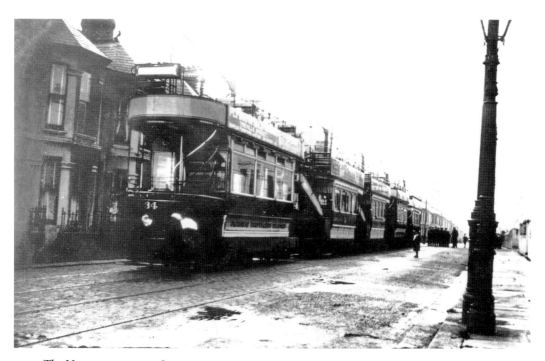

The No. 34 tram, *c.* 1928

You wait all day for a Tram and five come at once! Close to this tram route was Durnford Street which is steeped in history. Sir Arthur Conan Doyle assisted at a medical practice here and Sherlock Holmes was said to be based on his colleague, Dr Budd.

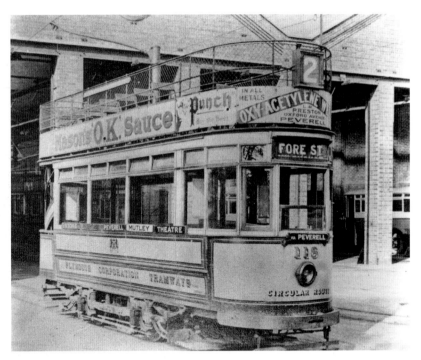

The No. 119 Tram at Milehouse Depot, *c.* 1930s
Here, a tram can be seen being maintained at Milehouse depot. This tram's
destination would have been Fore Street via Peverell. A member of the Plymouth
Corporation Tramways' fleet, these were beautifully decorated. This one carried
adverts for Masons OK sauce and *Punch*.

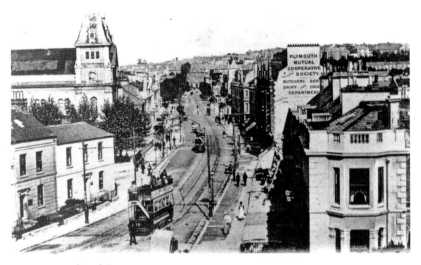

Trams at Mutley Plain, *c.* 1909
The tram at the front is the No. 19 and would have been part of the Plymouth,
Stonehouse & Devonport Tramways fleet. It has an advert for Fry's Cocoa on the side.
On the right of the picture is the Plymouth Mutual Co-operative & Industrial Society
building.

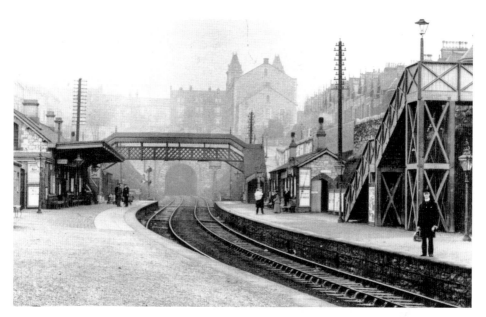

Mutley Train Station, *c.* 1910

Mutley station opened in 1849 and was closed in 1939. Some of the old buildings in the background are still very recognisable today. Mutley would have been a busy station as a stop-off point for the many shops and businesses on Mutley Plain and also for Plymouth College and several other schools and churches in the area.

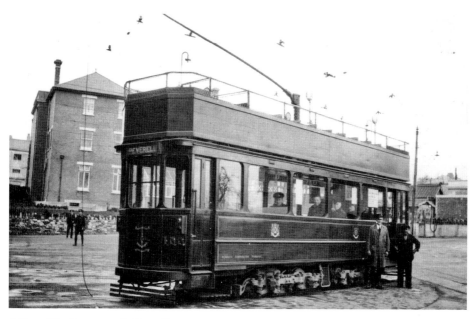

A Tram Heading towards Peverell, *c.* 1927

This tram was one of fifteen built by the Plymouth Corporation Tramways Department at Milehouse Depot in 1927 and 1928. They were built of teak as the manager thought they would look better as varnished wood rather than being painted over. Most of these trams lasted until 1945.

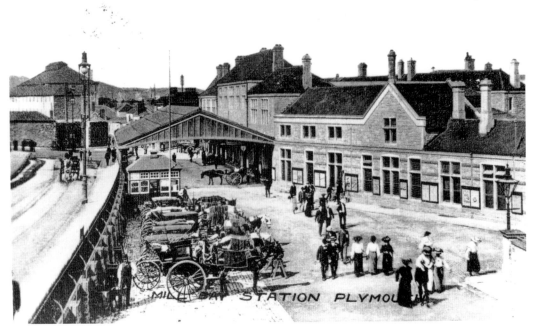

Millbay Station, *c.* 1905
Liner passengers would start their journey to London from Millbay Station. Many film stars including George Raft and Charlie Chaplin, would board the trains here with thousands of less famous travellers. Here, horses and cabs wait to take passengers to their hotels or next destination.

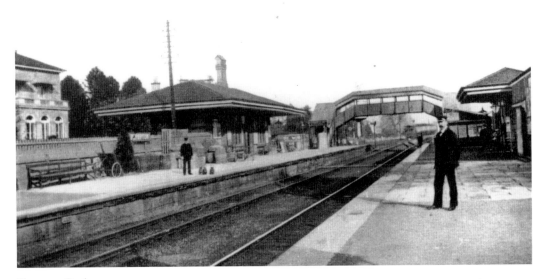

Plympton Station, *c.* 1910
A stationmaster waits for the next train to arrive. In 1904, the Great Western Railway started a new service between Saltash and Plympton. The same year also saw halts opened at Laira and Lipson Vale, and platforms were put in at St Budeaux and Ford.

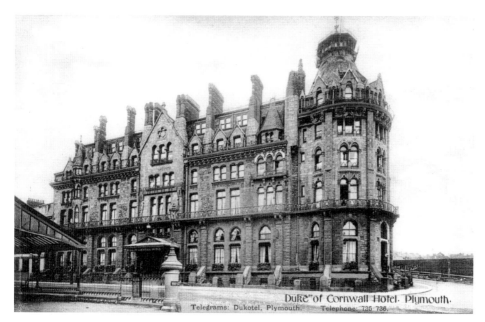

The Duke of Cornwall Hotel, *c.* 1910
Built in 1865 by John Pethrick, the Duke of Cornwall Hotel catered for passengers from the nearby Millbay station, either *en route* to London or travelling abroad via one of the liners at Millbay Docks.

Duke of Cornwall Hotel Advert, *c.* 1930s
The Duke of Cornwall Hotel advertised itself as 'the recognised Hotel for ocean passengers'. There were many of these disembarking from the many great ocean liners that landed at Millbay Docks.

Duke of Cornwall Hotel

Telegrams— "Dukotel" **PLYMOUTH** Telephone— 735

A.A. **FIRST-CLASS HOTEL** R.A.C.
PROVIDED WITH EVERY MODERN CONVENIENCE.
Recognised Hotel for Ocean Passengers. Near Docks, Hoe and G.W. Railway Station.

MODERATE CHARGES.

Bedrooms with Private Baths and H. & C. water. Central Heating. Lift to all Floors. Inclusive Terms.
Apply for Tariff to **MANAGER.**

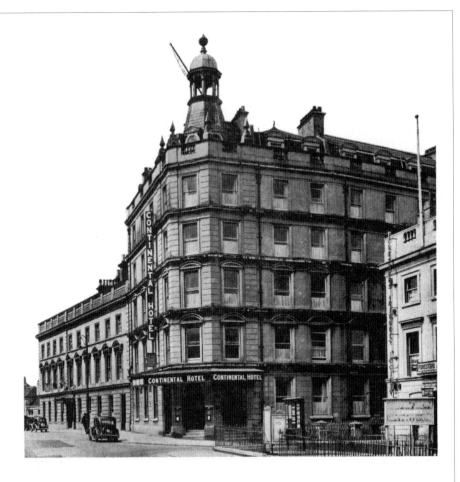

CONTINENTAL HOTEL

About half a mile from North Road Station (close to Millbay, now used only for goods) and convenient for most points of interest. Hot and cold water and gas fires in bedrooms

LARGE GARAGE TELEPHONE 342311

TRUST HOUSES LIMITED

[7]

The Continental Hotel, *c.* 1940s
The late 1820s saw a lot of activity at Millbay Docks and the Great Western Railway Company decided to build its Plymouth terminal nearby. With a large amount of passengers arriving at the station, it was decided to build a number of hotels to accommodate them. In 1875, the Albion Hotel opened its doors. The Albion adjoined the Royal Eye Infirmary, but this was later taken over by the owner of the Albion, George Fowler, and renamed Fowler's Hotel. By 1904, the two businesses had become collectively known as the Albion and Continental Hotels.

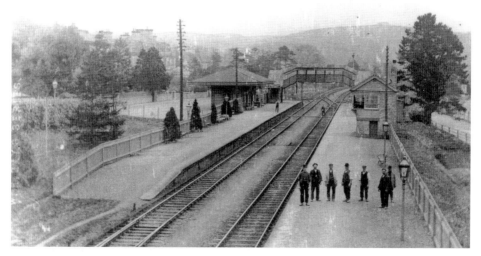

Plympton Station, *c.* 1910
A maintenance team pose for the camera. Plympton station was opened in 1848 by the South Devon Railway. It closed in 1959. The houses that can be seen in the background still stand today.

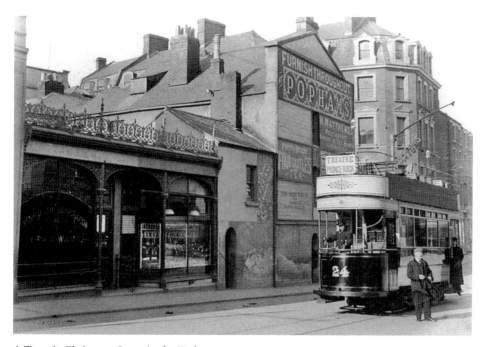

A Tram in Ebrington Street in the Early 1900s
Goulds now stands in the shop near to where the tram is pictured. Today, it's hard to imagine that there was ever a tram route travelling the length of Ebrington Street. Interesting adverts on the walls of the buildings include ones for Pophams, G. P. Skinner, H. Matthews' restaurant and Four Castles Tea.

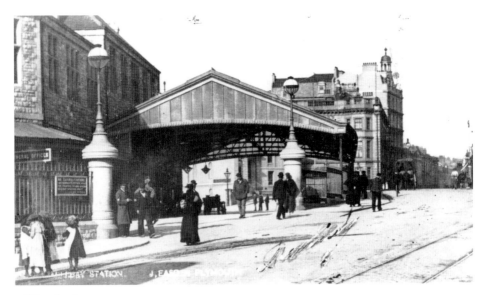

Millbay Station, *c.* 1905

The tracks ran from Millbay station straight into the docks. As well as VIPs, the trains carried various cargo from ships, including gold bars and spices. Built in 1849, it was nicknamed 'The Shabby Shed'. Millbay station closed to passengers in 1941 after being bombed and the platform lines were then used solely for goods traffic. In 1966, the line was closed completely to public goods traffic and finally, in 1971, the last track into Millbay Docks was closed.

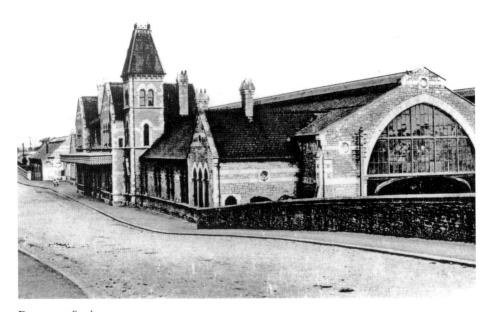

Devonport Station, *c.* 1910

Devonport station stood in King's Road where the College of Further Education now stands. Known as King's Road Station, the platforms were lit by gas lanterns. Many dockyard workers used the station and farm produce would arrive there to be taken to the nearby Devonport market.

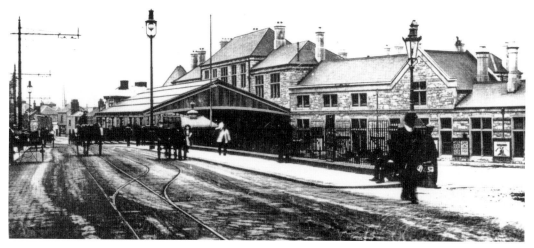

Millbay Station, *c.* 1910

A popular excursion leaving Millbay station was the sixpenny Woolworth trains heading towards Dartmoor. These would be so packed at times that passengers would be turned away. Evening trips would run to Newquay and St Ives. The site of the station is now occupied by the Plymouth Pavilions, an entertainment centre.

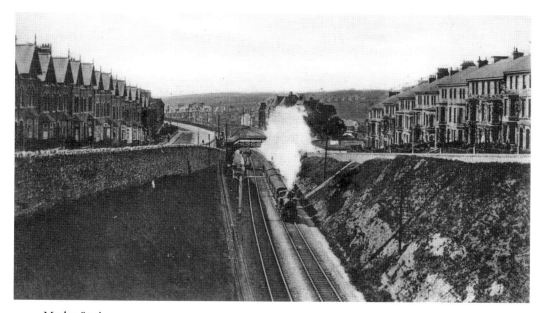

Mutley Station, *c.* 1912

A slope led down to the station and a cab would wait at the top to drop off or collect passengers. On Sundays at 4.30 p.m., day-trippers could catch one of the 'special' trains from Mutley station bound for Shaugh Bridge, Clearbrook and Yelverton.

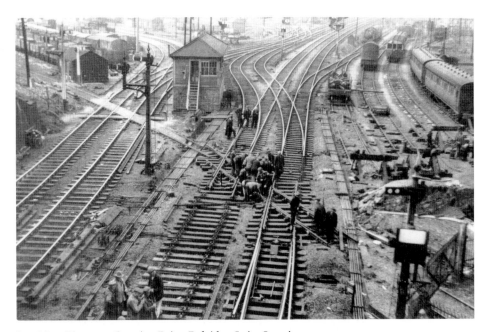

Lee Moor Tramway Crossing Being Relaid at Laira Junction, *c.* 1930s
Regular maintenance had to be completed to the lines, which were in constant use from the many trains and trams used at the time. At a time when there were few or no cars, nearly everyone travelled by rail.

Empty Wagons at Laira Yard, *c.* 1940s
These empty wagons are shown waiting to transport goods and produce across the region. These ones would probably have been used to transport china clay from Lee Moor to the docks at Laira Wharf.

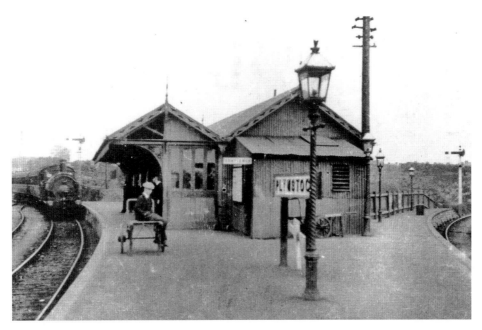

Plymstock Station, *c.* 1910

A young boy waits with a trolley to unload passengers' baggage. At one time, sixty trains passed by here a day on their way to Turnchapel or Yealmpton. Many of these stations had few staff, just a stationmaster and a couple of porters.

The Platform at Plymstock, *c.* 1950s

A stationmaster has a quick smoke and chat with the train driver. By 1930, passenger numbers had dwindled and the station remained open for freight only until 1960.

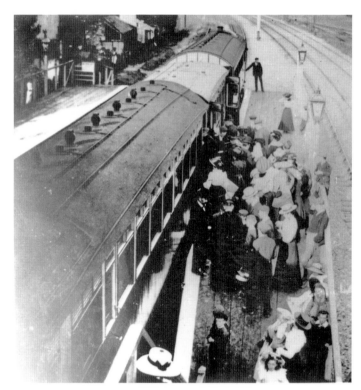

Laira Halt, *c.* 1905
A busy platform scene as commuters hurry to get on the train. Everyone seems to be dressed up for the occasion. Notice the young boys in their neat suits and white collars and the ladies in their large hats with bows on.

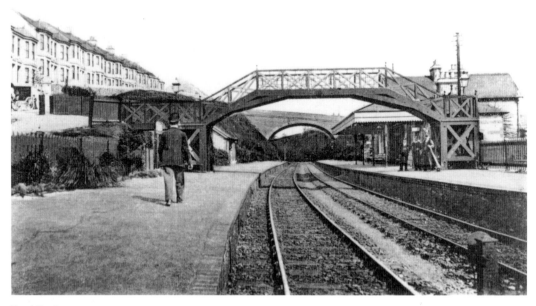

Ford Station, *c.* 1910
Ford station was opened on 2 June 1890 by the Plymouth, Devonport & South Western Junction Railway. It was closed on the 7 September 1964 and a housing estate now stands in its place. Notice the Edwardian gent on the left.

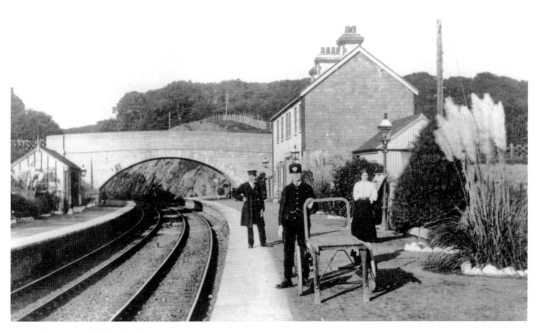

Tamerton Foliot Station, *c.* 1912
Now long since gone, the station at the time would have been considered as being out in the country. It can still be found at the end of a nature reserve but it has been a home dwelling for many years now. If you stand on the bridge today and look over, it really hasn't changed too much.

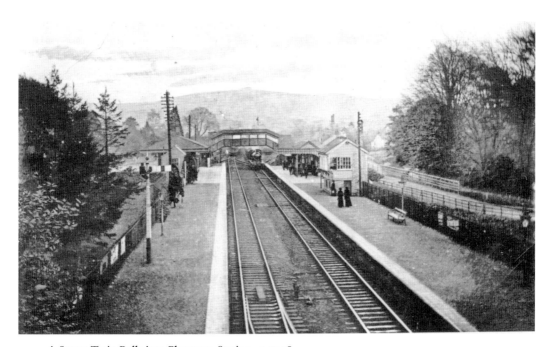

A Steam Train Pulls into Plympton Station, *c.* 1908
Great Western Railways, who had run many of the lines in Plymouth and the surrounding areas, ceased to exist on 31 December 1947 and the system became the Western Region of British Railways.

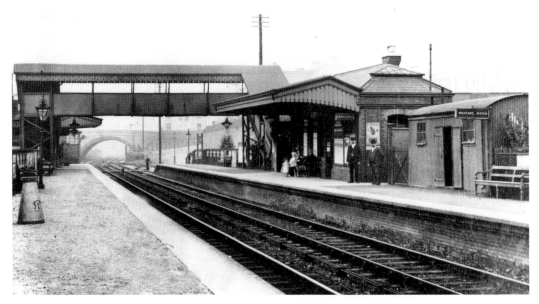

Keyham Station, *c.* 1910
Keyham station was opened on 1 July 1900 by the Great Western Railway. The station is still open but became unmanned in 1969. It was a well-used route for dockyard workers and sailors. The tin shed on the right is a waiting room and an old sign advertises 'Titleys'.

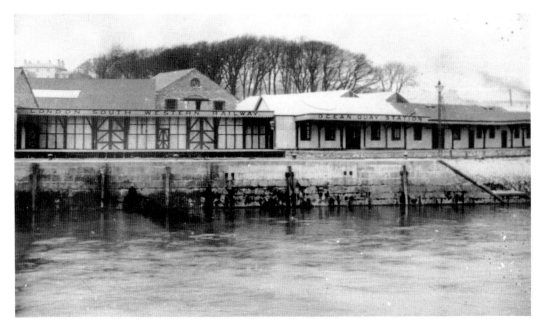

Stonehouse Pool Station, *c.* 1910
Devonport and Stonehouse station was opened in 1876 and a branch line led down to the Stonehouse Quay terminus. In the early 1900s, passengers would arrive here by tender from the great ocean liners moored nearby to be taken by railway to London. The sign reads, 'South Western Railway Ocean Quay Station'. An armaments factory was also situated nearby and during the First World War, troops would land there.

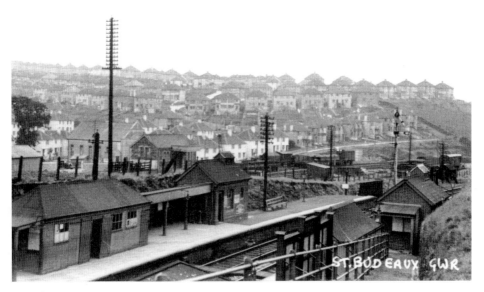

St Budeaux Station, *c.* 1930s
A popular station that serviced the ever-growing area of St Budeaux. It was used frequently by sailors and dockyard workers. It was also used by the many travellers who came to visit the picturesque Saltash Passage. When it first opened, the stationmaster was a Mr Edmund Tolley who lived in walking distance of the station.

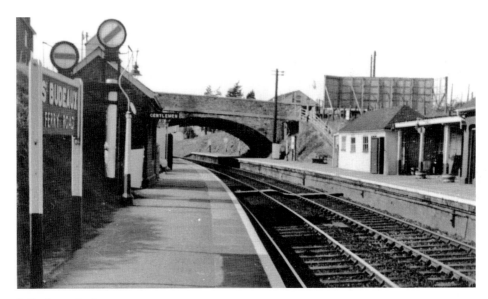

St Budeaux Station, c. 1930s
From St Budeaux Station you could catch a train to Saltash over the Royal Albert Bridge and be in Cornwall within minutes. For many years, this was the main route to Cornwall for travellers. The station opened on 2 June 1890 and the Reverend William Green, the local vicar, arranged for the church bells to be rung in celebration. The station was built by the Plymouth, Devonport & South West Junction Railway.

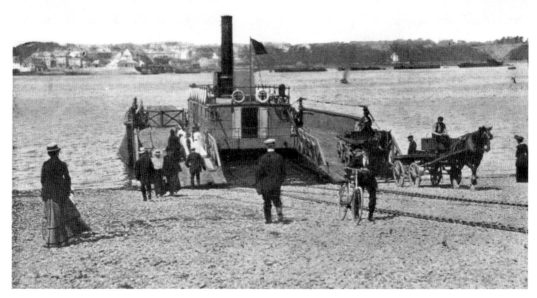

The Torpoint Ferry, *c.* 1910
The ferry first began its service in 1791 and was mainly used to bring the ever growing workforce to Devonport Dockyard. The fares were 1*d* for foot passengers, 2*d* for horses and a horse and cart was 1*s* 6*d*.

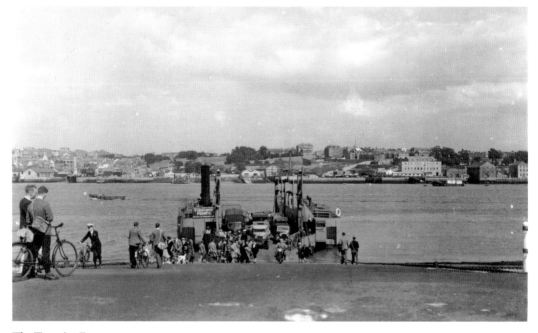

The Torpoint Ferry, *c.* 1940s
In 1834, James Rendel introduced a chain ferry to the crossing. Previously the ferry had been attached to rowing boats and later, in 1828, a short-lived steamboat had been introduced. The ferry became the property of the Cornwall County Council in 1922.

COMPLETE SERVICE
FOR YOUR CAR:

as modern as the Car you purchase.
New ideas, new equipment—every-
thing to give you a better job at a
lower cost.

IN THE HEART OF THE CITY
(St. Andrew Street).

We have erected a new super-service
station with the sole purpose of
giving the finest possible Service.
May We Serve You ?

W. MUMFORD, LTD

THE ABBEY GARAGE,
——————— PLYMOUTH.———————

Representing—
DAIMLER. WOLSELEY. LANCHESTER.
ALVIS. B.S.A. AUSTIN. MORRIS.

Mumford's Advert, *c.* 1933

Mumford's was probably one of the city's best-known garages. W. Mumford Ltd was founded
in 1900 and the company serviced cars in the city for many years after. Mumford's adapted
greatly over the years to deal with the many changes to transport particularly the great increase
in cars and other road vehicles.

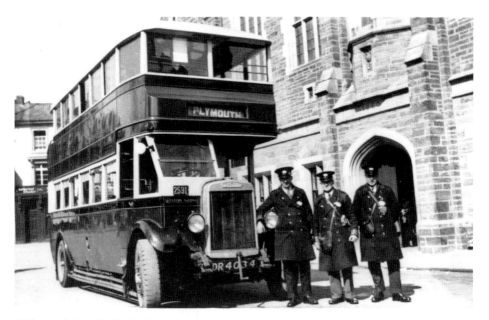

A Plymouth Double-Decker Bus, *c.* **1949**
A bus with its driver and two conductors pictured at Tavistock on their way back to Plymouth.
Notice how this bus has a crank to get it started. By 1922, motor buses were running in the
city and trams became a less viable proposition. In 1941, only the line from Drake's Circus to
Peverell still ran with trams but this was discontinued after the war and the city's last tram ran
on 29 September 1945.

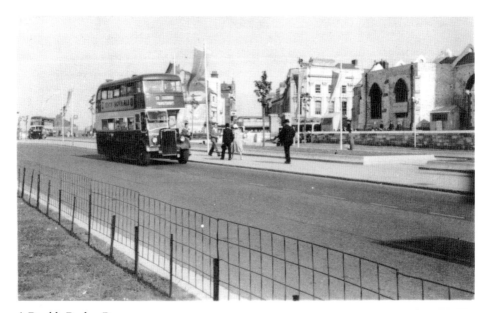

A Double-Decker Bus, *c.* **1947**
This photograph shows Royal Parade after the war, but before the new development took place.
Some buildings still stand in the picture, but these were later cleared to make way for the city
centre buildings that we see today.

"EXPRESS DELIVERY."

KINGSBRIDGE AND PLYMOUTH

VIA

CHURCHSTOW AVETON GIFFORD MODBURY YEALMPTON

TORQUAY
Every FRIDAY
Leave
Kingsbridge
about 9.30 a.m.
Torquay about 4 p.m.
via. Totnes and Paignton.

Van available
for other Trips
Mondays
and
Wednesdays

TUESDAYS, THURSDAYS, SATURDAYS

Leave **KINGSBRIDGE** about **9 a.m.** (Quay)

,, **PLYMOUTH** ,, **3.30** p.m. (Norley Yard)

We shall be pleased to convey Passengers and any class of Goods to and from Plymouth.

We give every care and attention to all Goods entrusted to us and our charges are moderate.

Parcels may be left at our Office in **MILL STREET** or our Van will call if we are notified.

We solicit your Orders, which shall have our prompt and careful attention.

A. BURGOYNE, :: MILL STREET, KINGSBRIDGE

LUGGER BROS. PRINTERS, KINGSBRIDGE

A Poster Advertising A. Burgoyne's Express Delivery Service between Kingsbridge and Plymouth,
c. **1930s**
Burgoyne's vans and lorries were a common site in Plymouth. Not only did they convey passengers and goods to and from Plymouth, but they were also responsible for transporting stone, coal and fertiliser from Plymouth's docks.

The Burgoyne Fleet, 1936

The Burgoyne fleet were regularly seen in Plymouth especially during the war when they helped clear up the debris from bombing in Devonport and Stonehouse. Huge areas of bomb damage existed in Plymouth and large areas such as the open space opposite King Street weren't developed until the 1980s.

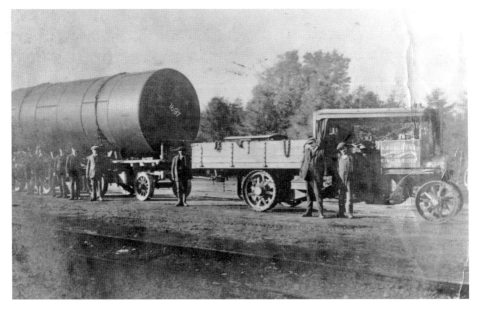

Alfred Burgoyne's Traction Engine, 1923

This photograph shows Alfred Burgoyne's new traction engine, bought in 1920. Taken in 1923, the photograph includes Bill Elliott (the driver), Alfred Burgoyne (the proprieter) and Christopher Tomas (the lead man in the goods yard). The engine features original storage tanks from the BP station at Kingsbridge. The truck later had sides attached and was used for conveying stones back and forth from Plymouth.

Devonport, the Dockyard and surrounding areas

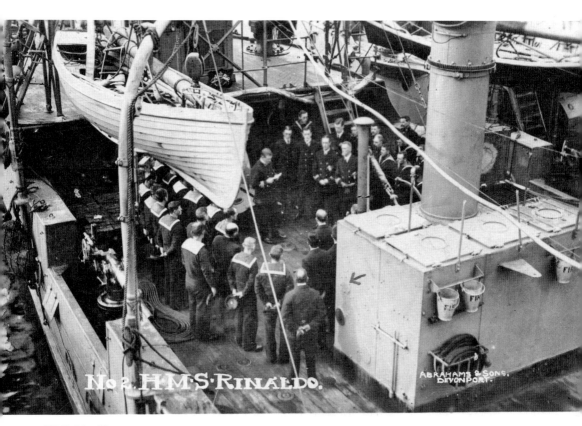

HMS *Rinaldo*, 1917
This photograph shows a service being held on board HMS *Rinaldo* at Devonport Dockyard.
HMS *Rinaldo* was a *condor*-class sloop launched in 1899. It was sold for scrap in 1921. This is
one of the many Naval ships that have carried the name HMS *Rinaldo* over the years.

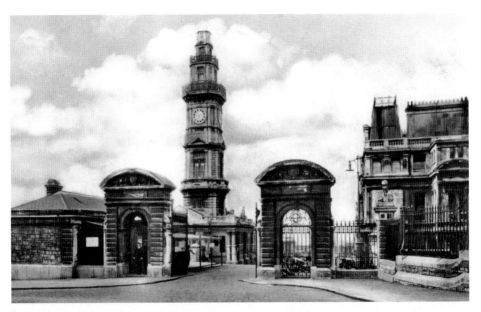

Naval Barracks, Keyham, *c.* 1920
This view is still recognisable today as the entrance to HMS *Drake*. Built of Portland stone, the original buildings from the 1800s included two accommodation blocks, a drill shed and a dwelling for the commodore.

NATIONAL
REGISTRATION

IDENTITY

CARD

National Registration Identity Card, 1939
National registration was introduced in September 1939 and during wartime everyone was issued with a card that they had to carry at all times. This one was issued to a civil defence warden working within the dockyard.

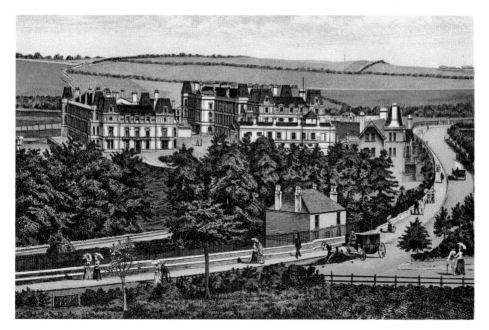

The Royal Naval Barracks, *c.* 1887
This early etching shows the then-newly-built Naval Barracks. Much has changed since then and a lot of the surrounding countryside has disappeared under houses built at Keyham, Devonport and St Budeaux. The road is still much the same though and leads off towards Camels Head.

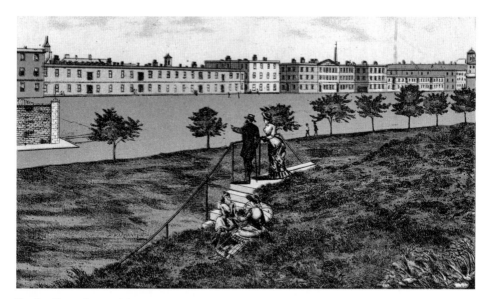

Raglan Barracks, *c.* 1887
Raglan Barracks was built between 1854 and 1858 and was named after the then Baron Raglan, James Somerset. It was built to accommodate two regiments, approximately 2,000 men and eighty officers. There was a rumour that the plans were destined for a tropical location, because the building had an unusual construction of yellow bricks with flat roofs and large balconies. In 1937, the War Office decided that it was out of date and should be demolished.

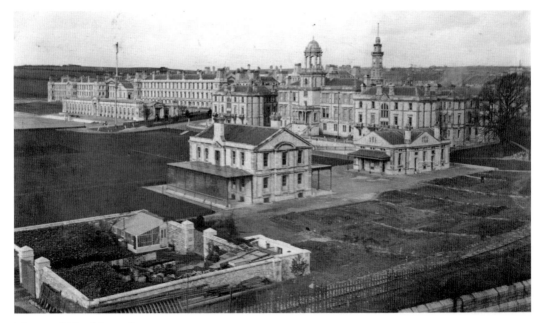

The Royal Naval Barracks, *c.* 1920

Work was started on the Royal Naval Barracks at Keyham in 1880. The total project cost £250,000 and the buildings accommodated 5,000 men. The clock tower was completed on 20 May 1896.

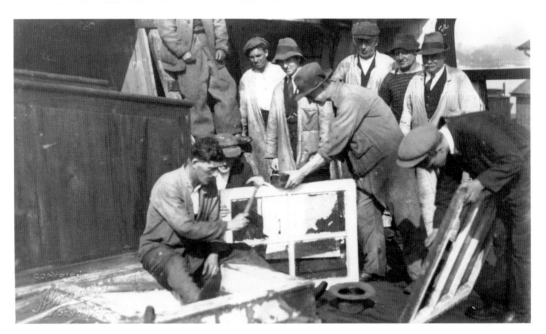

Edward Dart Planing wood in the Dockyard, *c.* 1920s

The first dockyard was built on the Hamoaze on the banks of the River Tamar in the late seventeenth and early eighteenth centuries. By 1712, there were 318 men employed there and by 1733, over 3,000 people were employed. The dockyard underwent major expansion in the late eighteenth and early nineteenth centuries as a result of the war with France.

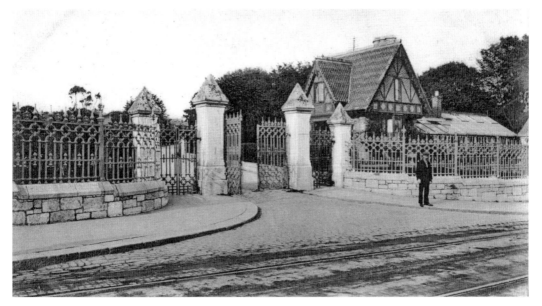

Devonport Park, *c.* 1908
Devonport Park was built in 1858. Seen here at the entrance to the park in Stoke Road is the Swiss Lodge, which was designed by Alfred Norman of Devonport. In the 1860s, the park was rented by Devonport from the War Office for a yearly sum of £65.

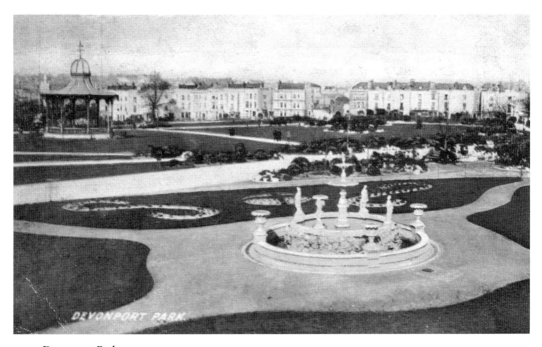

Devonport Park, *c.* 1910
Devonport Park stretches for 37 acres. Originally there was a bandstand in the park, which, in the summer months, would be visited by local regiments and volunteers, who would entertain the public.

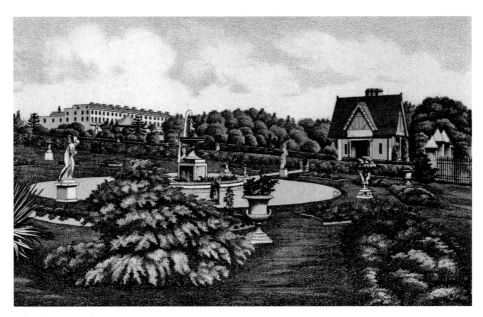

Devonport Gardens, _c._ 1887
An early etching of the park showing the Swiss Lodge and the main fountain. The park was later extended and improved in 1894. The main walk follows an old trench that use to surround Granby Barracks.

Edward Dart on his Allotment in Stoke, 1939
Allotments played a vital part in food production in the Second World War. Between the wars, there had been a drop-off in interest in allotments and much of the land was used for houses.

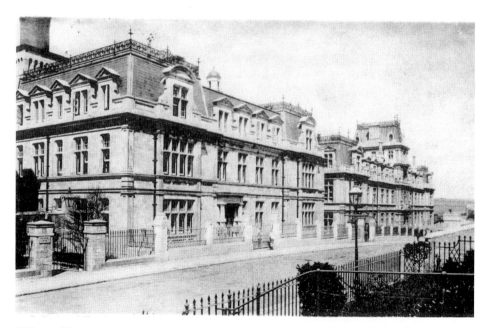

College of Engineering, *c.* 1910
The college opened on 1 July 1880 as a training school for engineer students. It was occupied by 120 students, who were given board and lodge. They would spend five years there before being drafted onto seagoing vessels as assistant engineers.

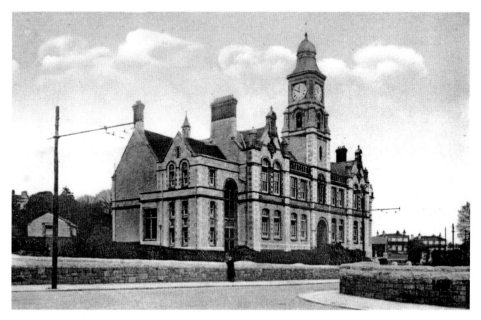

Devonport Technical School, *c.* 1910
The school was opened on 25 July 1899 by the Mayor, W. Hornbrook. Technical schools were unheard of before the nineteenth century. Until 1936, Devonport Technical housed the Devonport Municipal Secondary School for Girls – later Devonport High School for Girls.

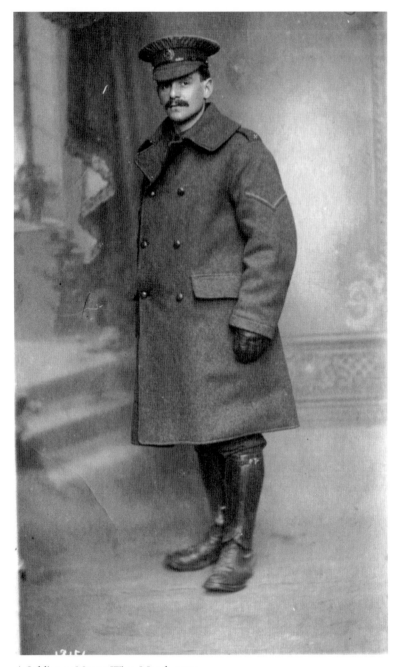

A Soldier at Mount Wise, March 1915
Shown here is Lieutenant William Lockwood Lang of the 30th Corps Royal
Engineers motorcycle division, stationed at Mount Wise.

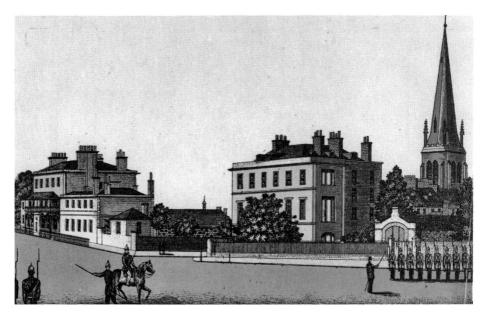

Mount Wise, *c.* 1890s.
Mount Wise consisted of twenty-one detached buildings. It included workshops for many tradesmen including joiners, smiths and harness-makers all employed to build up stores for military use. Officers' houses stood on the eastern side.

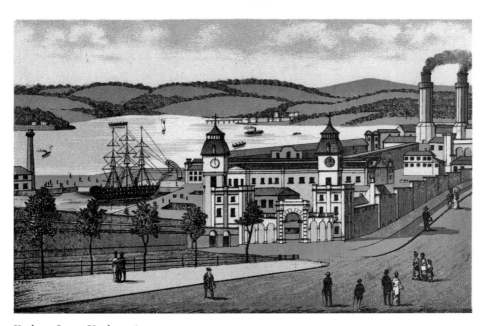

Keyham Steam Yard, *c.* 1877
In the 1830s, a quarter of the Navy's vessels were powered by steam and a new yard was built to service them. Work started in 1845 and the site occupied 72 acres. The total cost of the project was £1,333,000. In October 1853, Queen Victoria attended the opening of the Keyham Steam Yard extension.

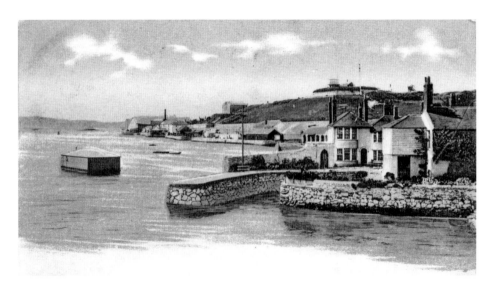

Mount Wise, *c.* 1912
Sir Thomas Wise owned the Manor of Stoke Damerel and had a manor house at Keyham. When Mount Edgcumbe House was built in 1547, Sir Thomas decided to build a Tudor dwelling looking out to sea, which he named Mount Wise. For many years, the maritime headquarters at Mount Wise served as a Naval reserve training centre known more commonly in the Royal Navy as HMS *Vivid*. It was formally commissioned in 1959. The unit had a total of 250 reservists.

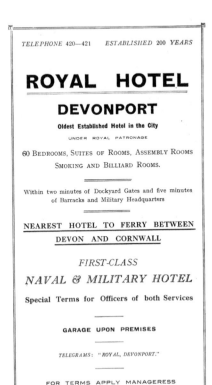

Royal Hotel Advert, *c.* 1931
The Royal Hotel at Devonport boasted that it was the oldest established hotel in the city and dated from the 1700s. It had sixty bedrooms and catered for many military personnel.

CHAPTER EIGHT

Outskirts

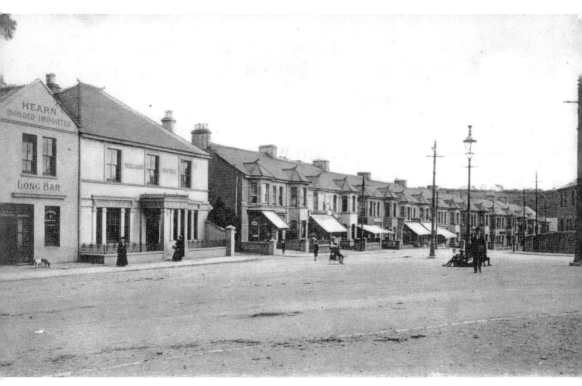

The Trelawny Hotel and Terrace, St Budeaux Square, *c.* 1910
The area is still recognisable today, although the advent of cars and an increasing population has made this a very busy area. The building directly to the right of the hotel was once a coaching stable. General John Jago Trelawny who owned the Barne Estate, sold this site to Joseph Stribling for £167 and the hotel was built in 1895. The Trelawny Hotel, later the Trelawny Arms, is still there, but nowadays is closed and boarded up.

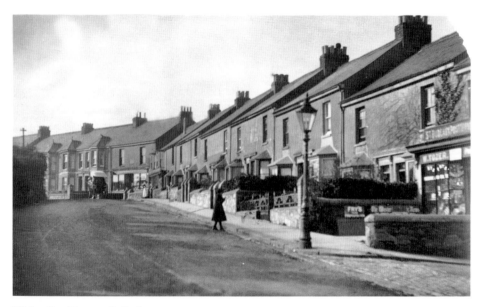

Higher Lea Terrace, St Budeaux, *c.* 1910
Located at the top of Higher St Budeaux, this road and its houses have changed little in the last hundred years. The shop seen on the right was once owned by W. Tozer and was St Budeaux's post office.

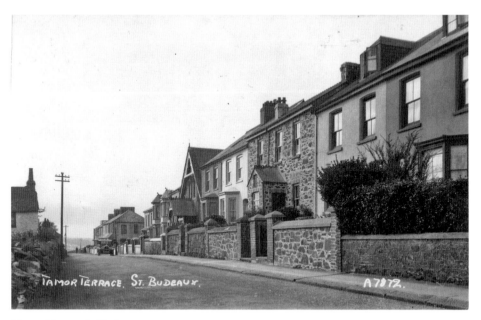

Tamar Terrace, St Budeaux, *c.* 1920
Still very recognisable today, all of these houses still remain, although more houses have now been built on the left of the picture. For years, this road was the main route for car travellers to the Tamar Bridge, but with the building of the Parkway the road was shut off at the far end.

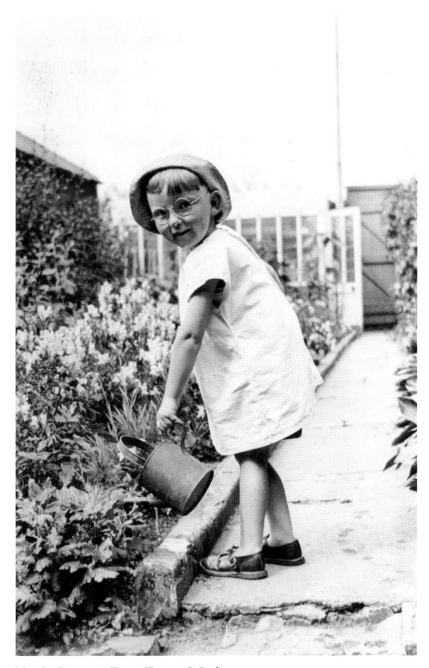

Maurice Dart at 16 Tamar Terrace, St Budeaux, *c.* 1930s
This photograph shows Maurice Dart watering plants in his garden at Tamar Terrace. Tamar Terrace was later renamed Normandy Way after the Second World War servicemen who marched this way to leave for Dunkirk from Saltash Passage.

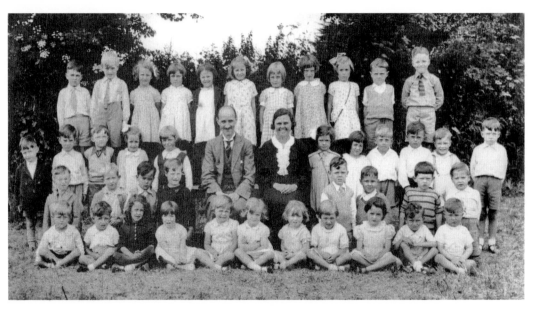

St Budeaux School Infants, 1937
Headmaster Mr Ewart Prior and teacher Miss Ingram. Maurice Dart is in the third row, third from the left. Mr Prior was a very popular headmaster and his brother was headmaster of a nearby school.

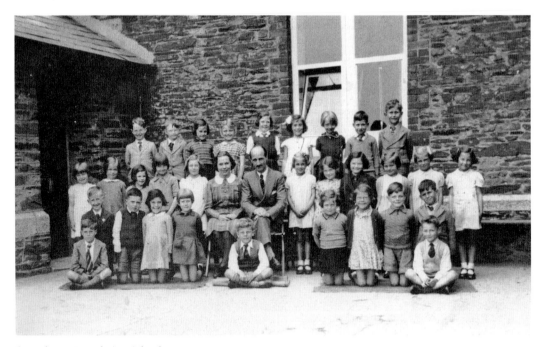

St Budeaux Foundation School, 1939
Ewart Prior is seen here as headmaster with Miss Packer as the class teacher. Maurice Dart is in the back row, second from the left. St Budeaux Foundation School was founded in 1717. It was originally located at the village green at Higher St Budeaux, but was rebuilt in 1876 at the top of Victoria Road. It was demolished in the early 1980s when the new road to the Tamar Bridge was built.

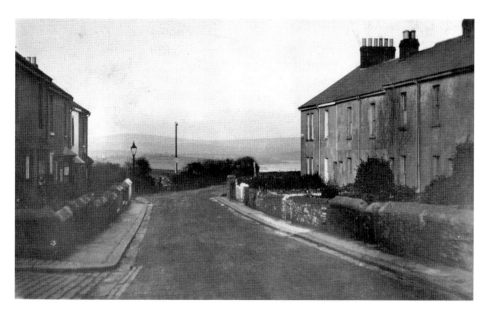

Ernesettle Road, *c.* 1910

These houses still stand and look similar to when they were first built. However, traffic has increased significantly over the years and in the distance where you can see open countryside and the River Tamar, the Parkway now cuts through the land, taking travellers to Cornwall over the Tamar Bridge.

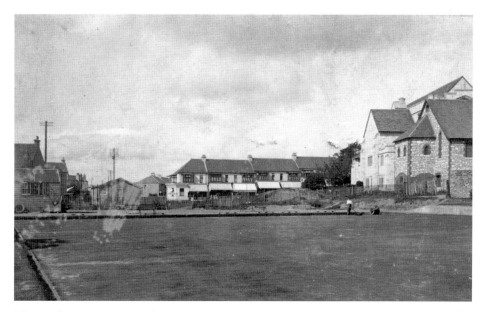

The Bowling Green at St Budeaux, *c.* 1910

The bowling green was situated behind where St Budeaux library stands today. The shops in the background are easily recognisable today and form the lower part of Victoria Road. The shop on the corner would have been Northcott's bakery. On the right of the picture is St Boniface Church, which was demolished in 2003. Also in the picture is Victoria Road School.

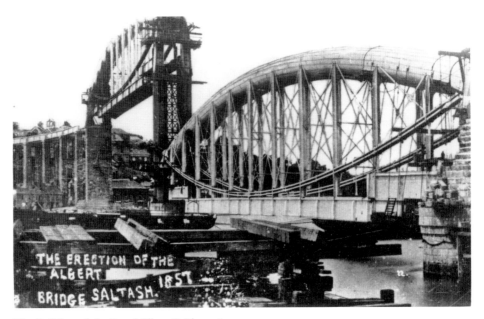

The Building of the Royal Albert Bridge, 1857

Designed by Isambard Kingdom Brunel, the total length of the bridge is 2,200 feet and it has two main spans of 455 feet, each weighing 1,060 tons. The total construction cost was £255,000. Brunel died shortly after its construction in September 1859, aged fifty-three.

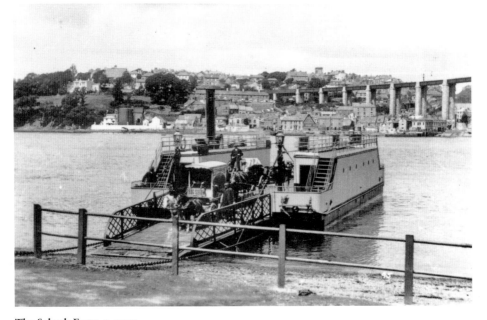

The Saltash Ferry, c. 1905

The ferry was originally known as the Ashe–Torre Passage. Ashtorre was the old name for Saltash and the Saltash Passage side was known as Esses Torre. The road that runs behind the Royal Albert Bridge Inn has been the main route to Cornwall for centuries.

BRISTOL & EXETER RAILWAY.

VISIT

OF HIS ROYAL HIGHNESS

THE PRINCE CONSORT,

TO THE

OPENING

OF THE

ROYAL ALBERT BRIDGE,

AT

SALTASH,

ON

MONDAY, 2nd May, 1859.

ROYAL TRAIN TIME BILL.

DOWN	DEP. A.M.	ARR. A.M.	UP	DEP. P.M.	ARR. P.M.
WINDSOR	6 0		SALTASH	—	
Bristol		8 35	Cornwall Junction		—
" 	8 45		"	6 50	
Taunton...		9 35	Newton		—
" 	9 38		" 	—	
Exeter		10 25	Exeter		8 15
" 	10 35		" 	8 25	
Newton		11 5	Taunton...		9 12
" 	11 10		" 	9 15	
Cornwall Junction		12 0	Bristol		10 5
"	12 5		" 	10 15	
SALTASH		12 15	WINDSOR		12 50

The following arrangements will be necessary for the proper working of this Train, which must be strictly attended to:—

The 7.50 a.m. Down Passenger Train is to Shunt at Tiverton Junction.

The 8.0 a.m. Goods Train Down will not start from Bristol until after the Royal Train.

The 8.0 p.m. Up Train is to Shunt at Tiverton Junction.

The 9.20 p.m. Short Train from Weston is to Shunt at Yatton.

BRISTOL, 29th April, 1859.

Opening of the Royal Albert Bridge, 1859
The bridge was opened on 2 May 1859 by His Royal Highness Prince Albert. Brunel was unable to attend due to illness, but later saw the bridge shortly before his death.

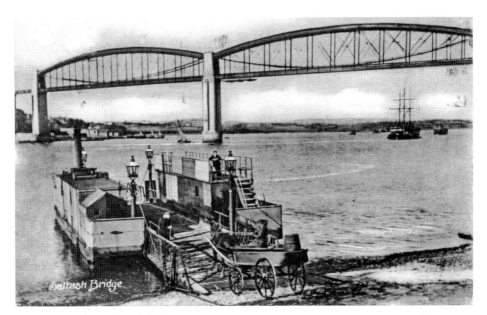

The Saltash Ferry, *c.* 1900
Until the early 1900s, Saltash Passage was part of Cornwall. There had been a ferry link from Saltash Passage, on the Plymouth side, to Saltash for 600 years, and the Brunel Bridge marks the old route of the ferry. When Brunel completed the bridge in 1859, the ferry moved further downriver to just in front of the Ferry House Inn.

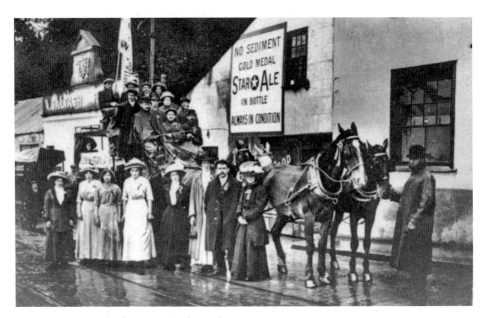

A Coach Trip at Saltash Passage in the Early 1900s
This horse and coach can be seen outside the Ferry House Inn in Saltash Passage. The area is instantly recognisable today. In the background can be seen the old waiting room for the ferry. It's still there today, although the ferry hasn't been in service since 1961. Many descendants of the people pictured in this photograph still live in Saltash Passage.

Maurice Dart at Saltash Passage Steps, *c.* 1930s
These steps at Saltash Passage are still there and lead down to the shore beside the children's park underneath the bridge. Here, a young Maurice Dart decides whether or not to go in for a paddle.

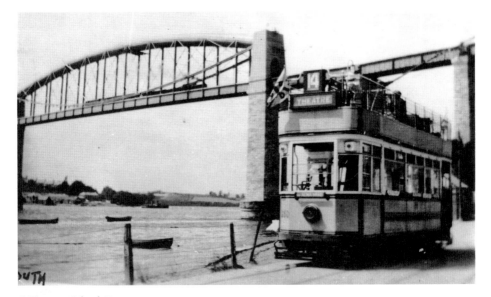

A Tram at Saltash Passage, *c.* 1923
Saltash Passage would have been the last stop by the river before this tram headed off back into the town. In 1923, the line was extended from St Budeaux along a track that had been closed since the First World War. The trip from the pier to Saltash Passage covered a remarkable 9 miles and was the longest journey in the city. The fare was 4*d*. This one is marked 'Theatre' and its final destination would have been by Derry's Clock.

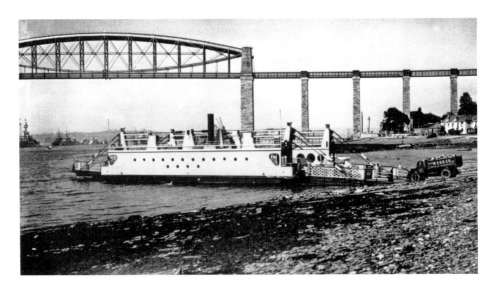

The Saltash Ferry by the Royal Albert Bridge, *c.* 1940s
A truck belonging to 'Webber Ltd' boards the ferry. The Royal Albert Bridge Inn can be seen on the right of the picture. The tea gardens at Saltash Passage, known as Little Ash Tea Gardens, were described as 'Devonport's Beauty Spot' and featured swings, a roundabout and see-saws. Combined with the St Budeaux Regatta on the Tamar, the tea gardens boasted 20,000 visitors in one summer. The tramways band would play and the tea gardens were promoted as offering 'High Class Teas and Refreshments at Popular Prices'.

Acknowledgements

Thanks to Maurice Dart and his extensive collection of photos, and to Eric Webb, Madeleine Slater, W. H. Burgoyne, Tina Cole, John and Joyce Cole, Florence Colton, Ivy Graddon, Marshall and Sally Ware, the Park Pharmacy Trust, Derek Gigg, Eileen Cock, Neil Hinkley, Bob and Helen Williams, Brian Moseley and A. J. Marriot for all their help and for supplying photographs for this publication.

Thanks also to H. J. Heinz Company Ltd, Mumford's, the New Continental Hotel, Jaeger, Goodbody's, The Duke of Cornwall Hotel, The Grand Hotel and Boots for their permission to use the adverts featured in this publication.

I have done my best to track down the owners of the copyright for all images used and apologise to anyone not mentioned.

I would be interested to hear from anyone who has old photographs, adverts, documents etc. concerning Plymouth that could be used in future publications. I am particularly interested in items from the early 1900s until the late 1970s. Please contact me at:

Derek Tait
PO Box 7
West Park
Plymouth
PL5 2YS

or email me at *derek.tait@virgin.net*

Bibliography

Plymouth: A Pictorial History by Guy Fleming (Phillimore & Co Ltd, 1995)
A Century of Plymouth by Guy Fleming (Sutton Publishing, 2000)
Laurel and Hardy – The British Tours by A. J. Marriot (A. J. Marriot, 1993)
The *Through the Lens* series by Brian Moseley (Brian Moseley, 1989-93)
The Trams of Plymouth by Martin Langley and Edwina Small (Libris Press, 1992)
Millbay Docks by Martin Langley and Edwina Small (Devon Books, 1987)
The Ancient Parish of St Budeaux by Marshall Ware (Arthur Clamp 1983)

Newspapers:

The *Evening Herald*
The *Western Morning News*

Websites:

Brian Moseley's Plymouth Data website at *www.plymouthdata.info*

Steve Johnson's Cyberheritage website at *www.cyberheritage.co.uk*

Applause Southwest at *www.applausesw.org.uk*

The Wheal Martyn website at *www.wheal-martyn.com*